The Cute Ninja Coloring Book

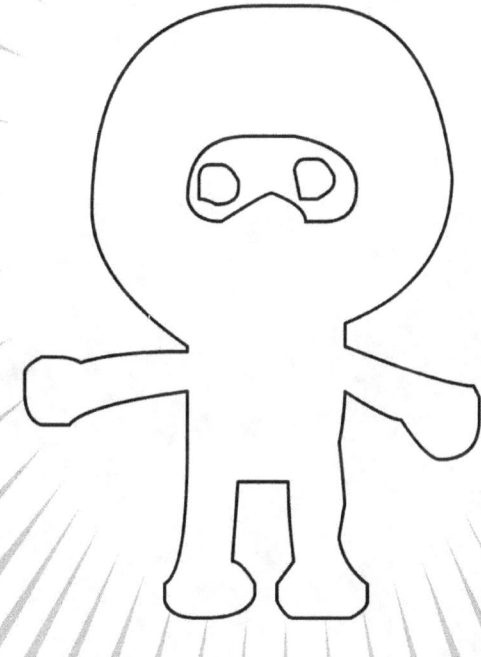

by
Michael Anthony Carroll

The Cute Ninja Coloring Book

Copyright © 2016 Michael Anthony Carroll

All rights reserved.

ISBN: 153749967X
ISBN-13: 978-1537499673

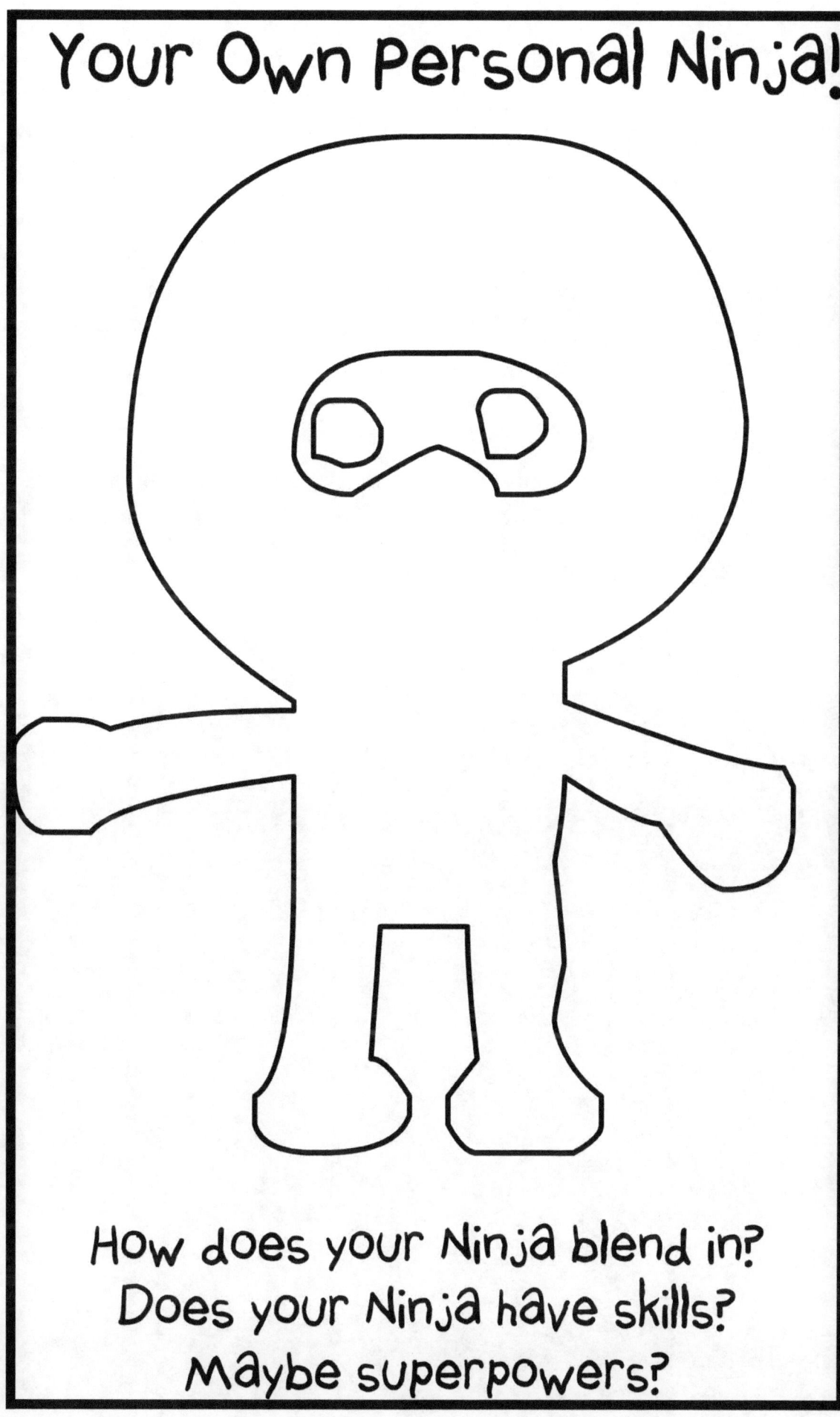

Your Own Personal Ninja!

How does your Ninja blend in?
Does your Ninja have skills?
Maybe super powers?

Your Ninja Clan!

**Do they dress the same?
What are their powers and skills?**

Stuff Ninjas Like to Eat

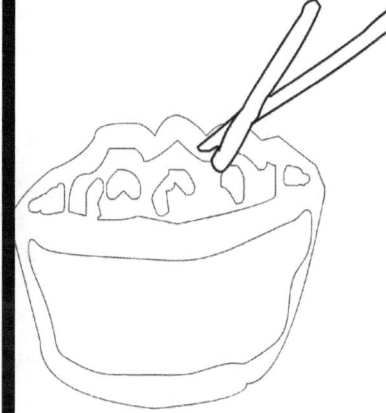

Rice Bowl
(with chopsticks)

Black Bean
Ninja Burrito

Ninjammon Roll

Ninjer Ale

Ninja Weapons and Things

Ninja Sword

Throwing Stars (Shuriken)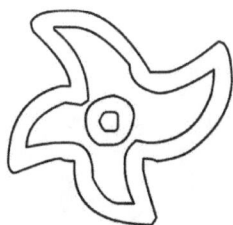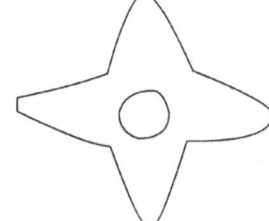

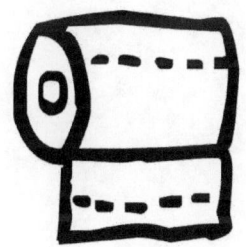 Two Ply Ninja Shhh Paper

Ninja Fishhh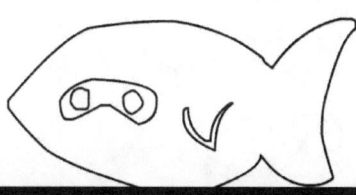

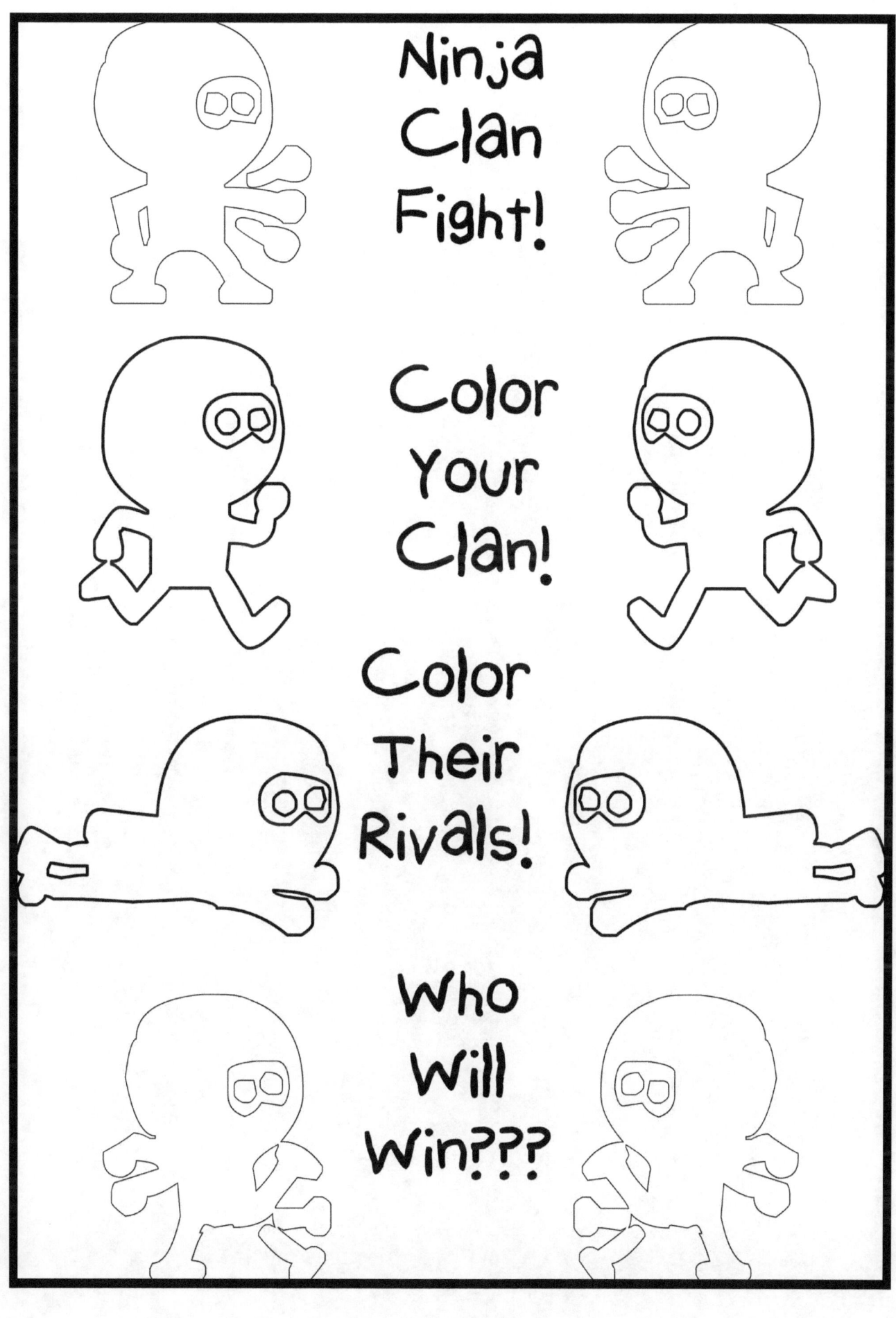

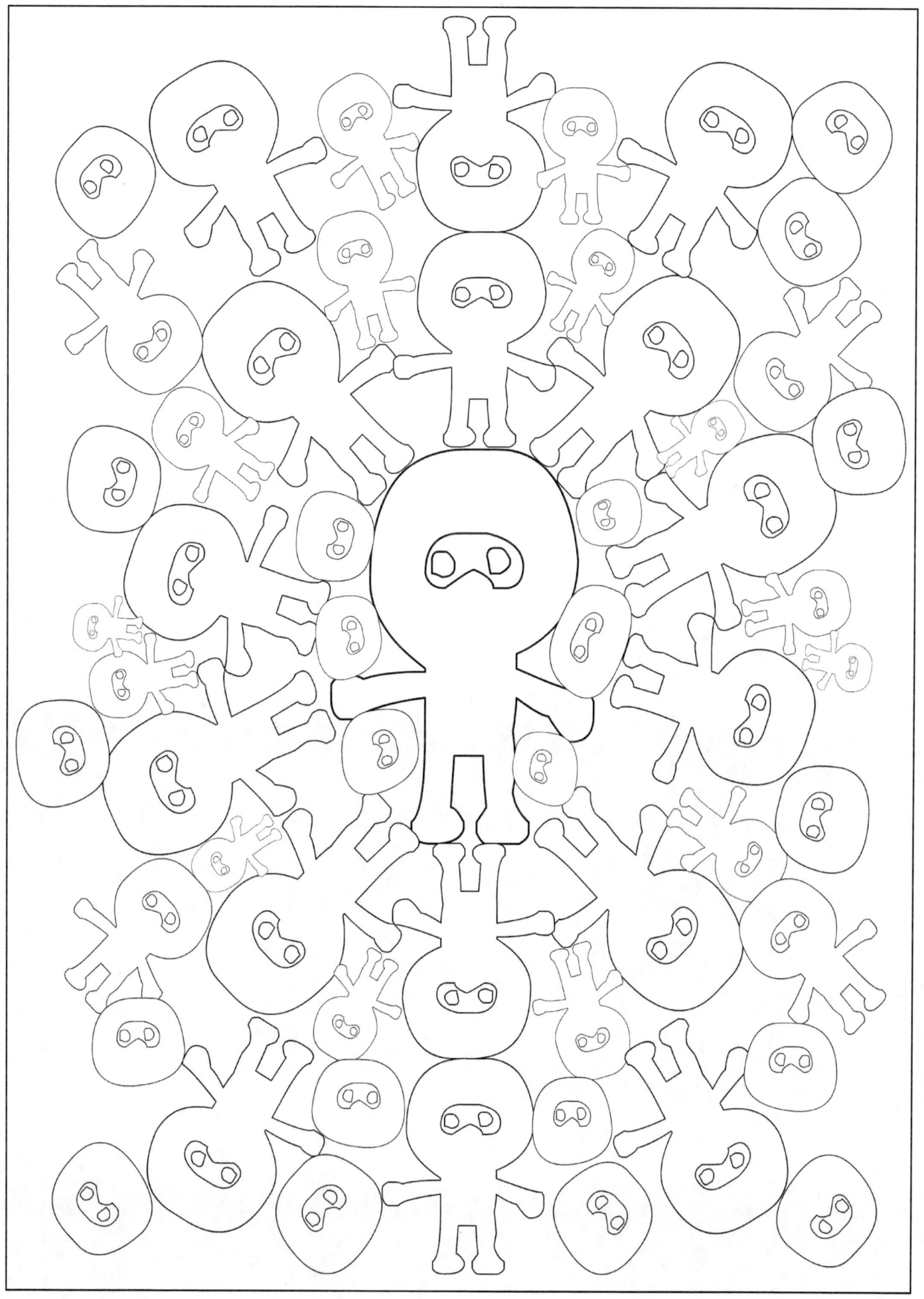

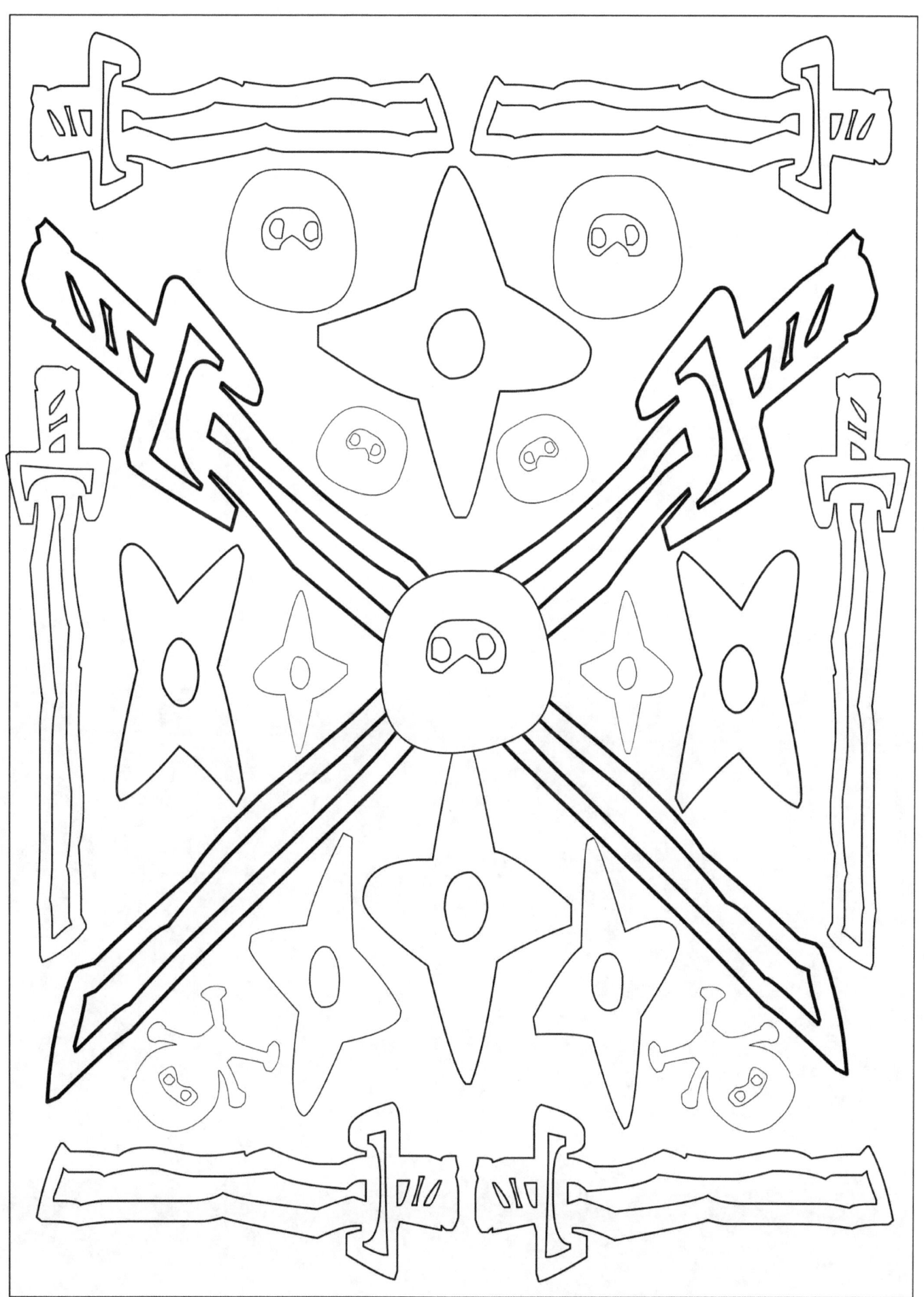

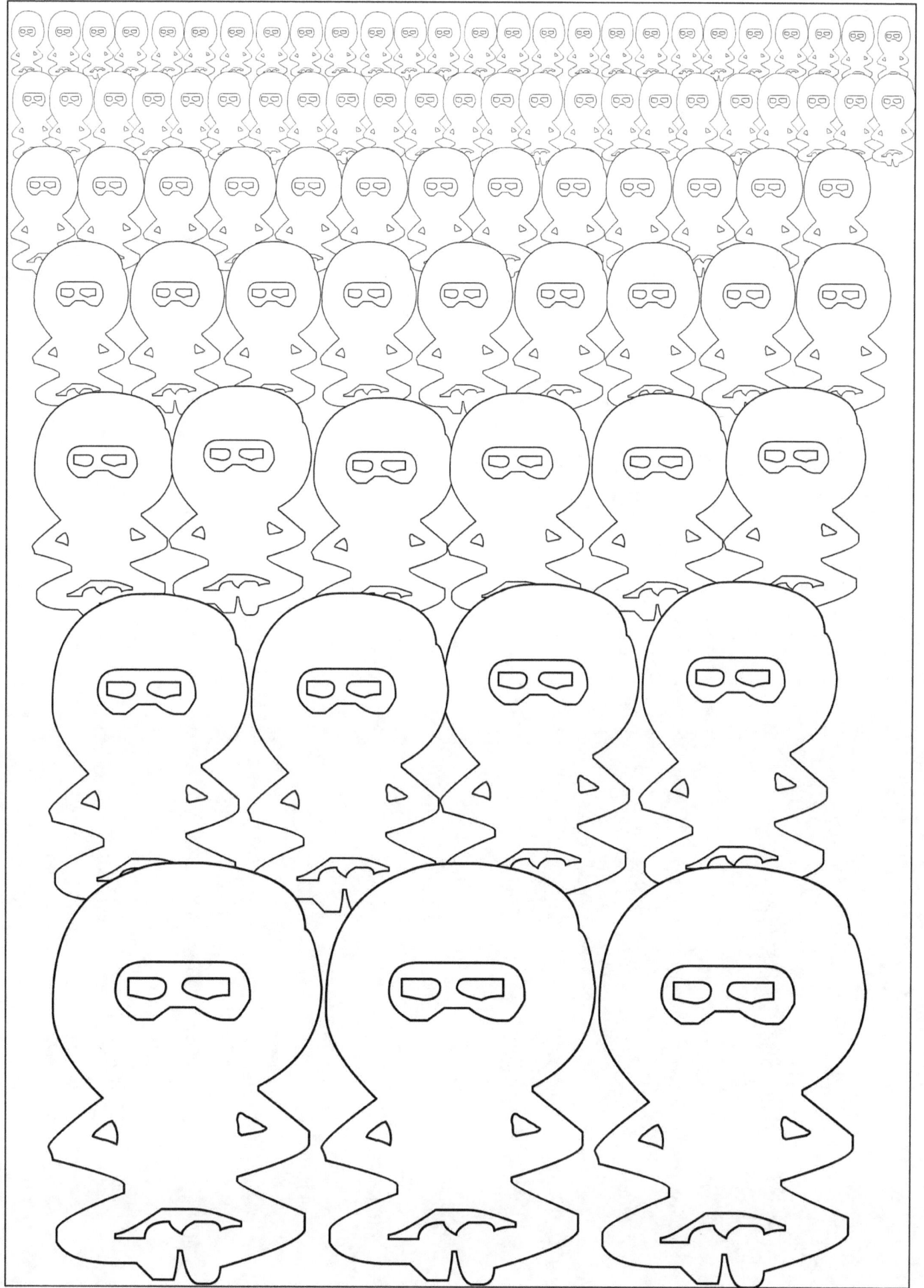

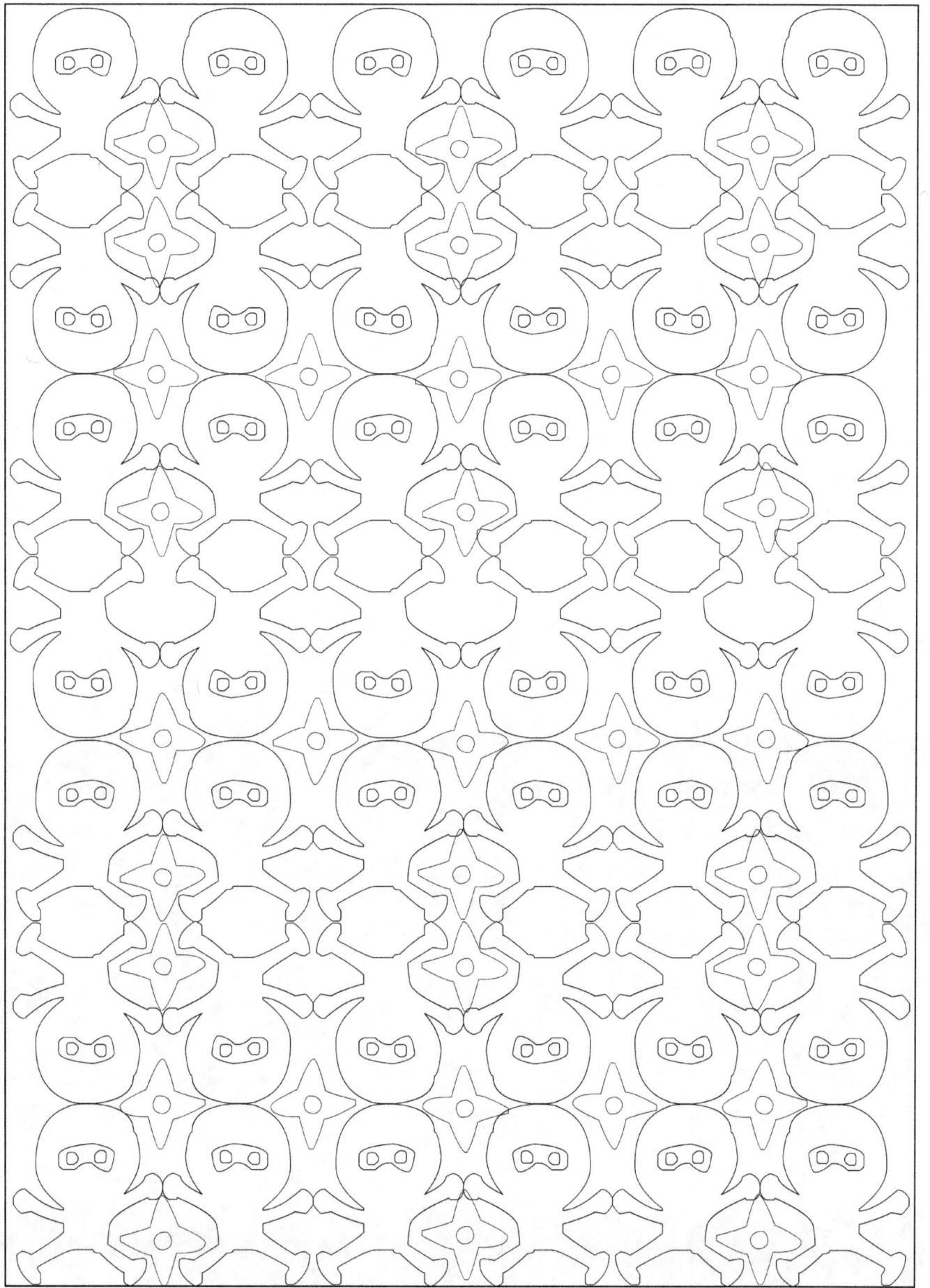

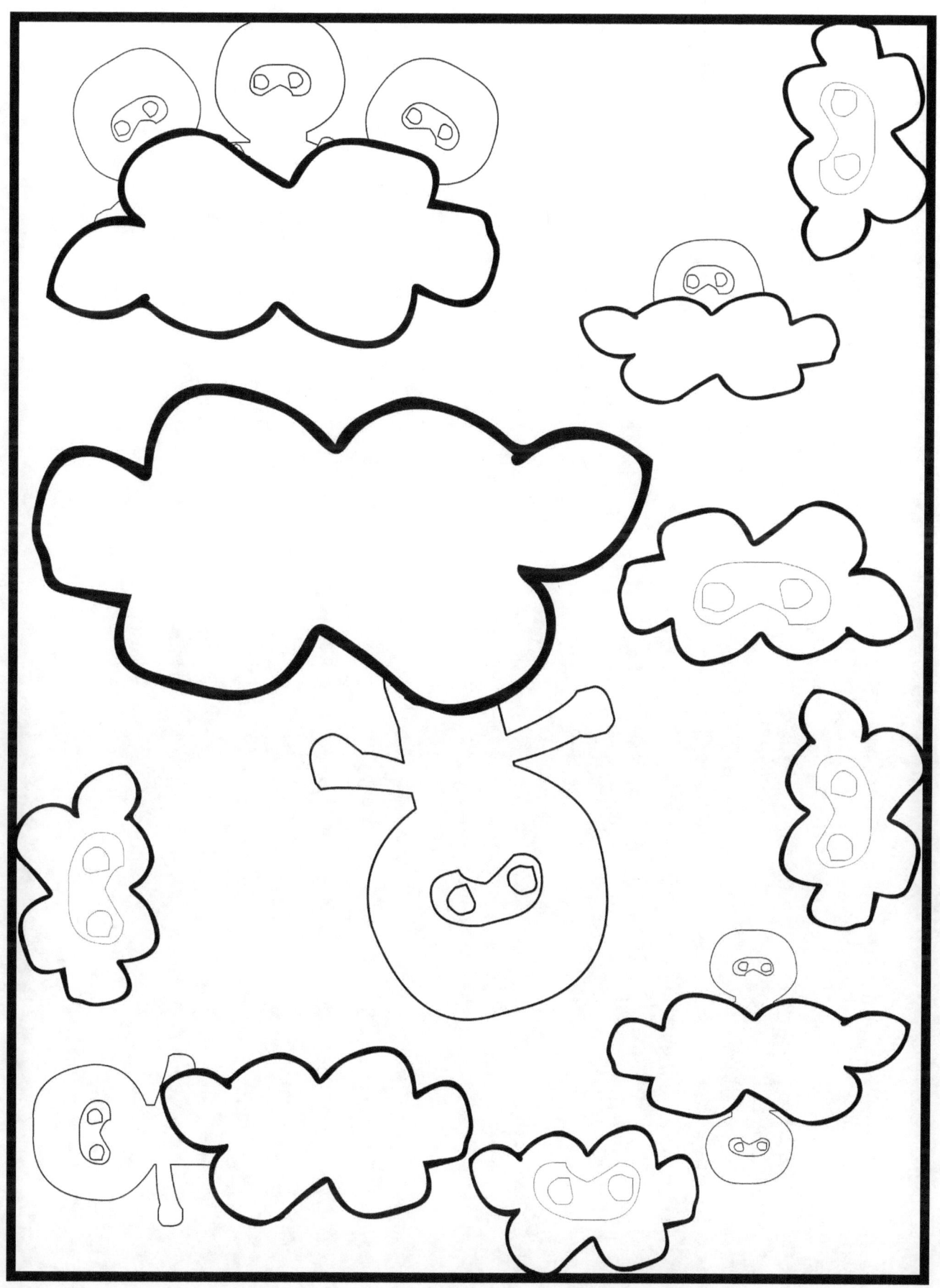

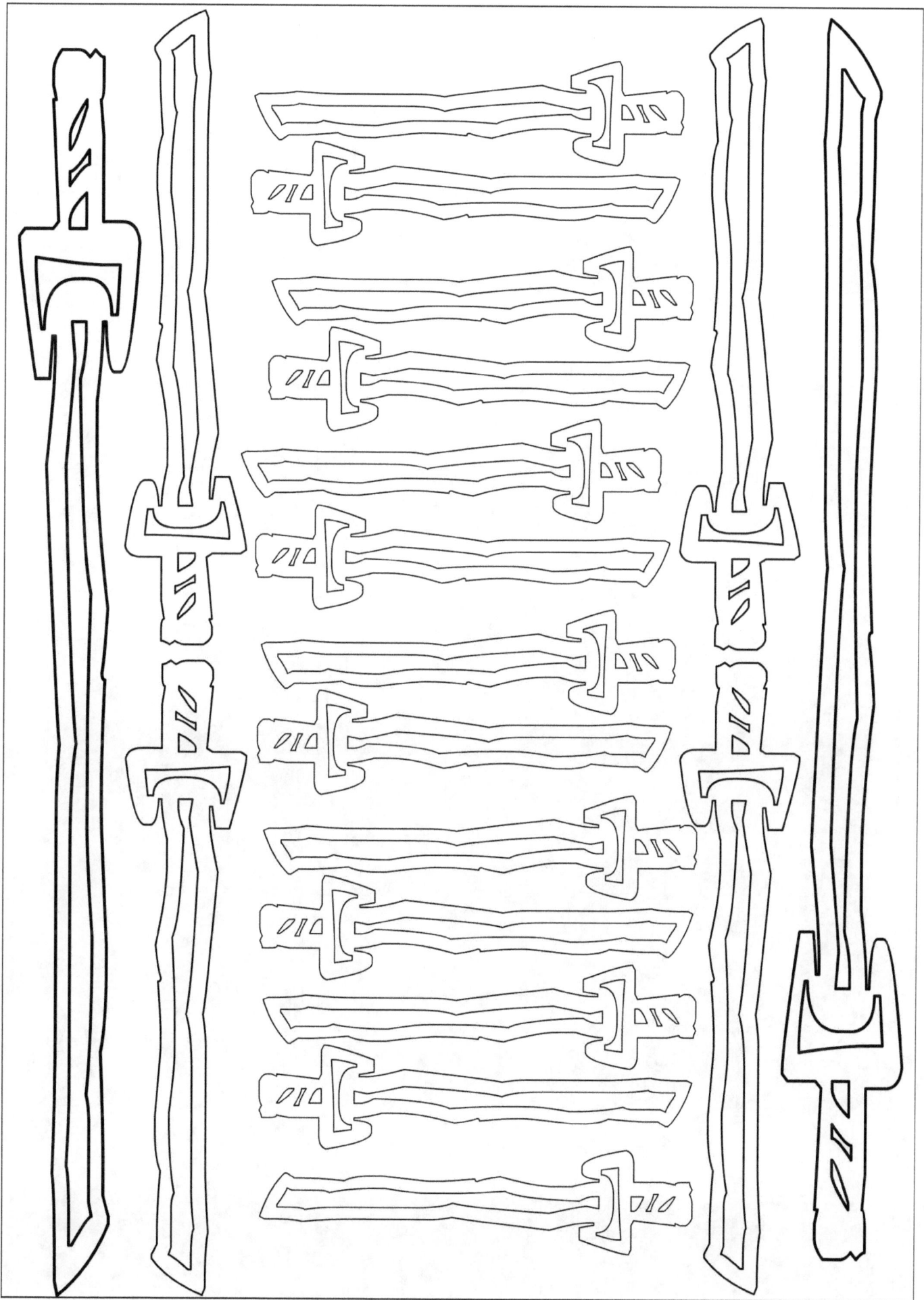

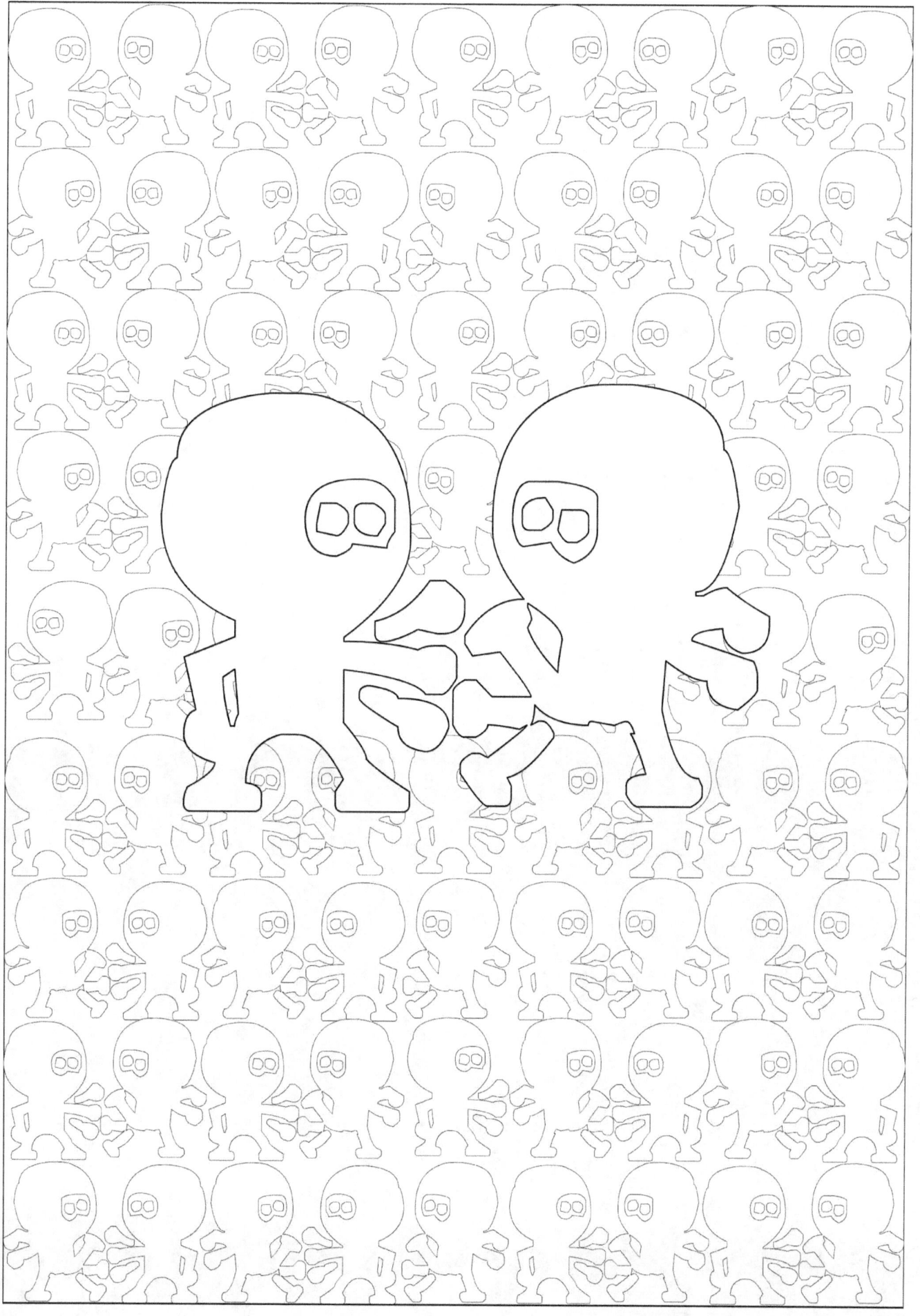

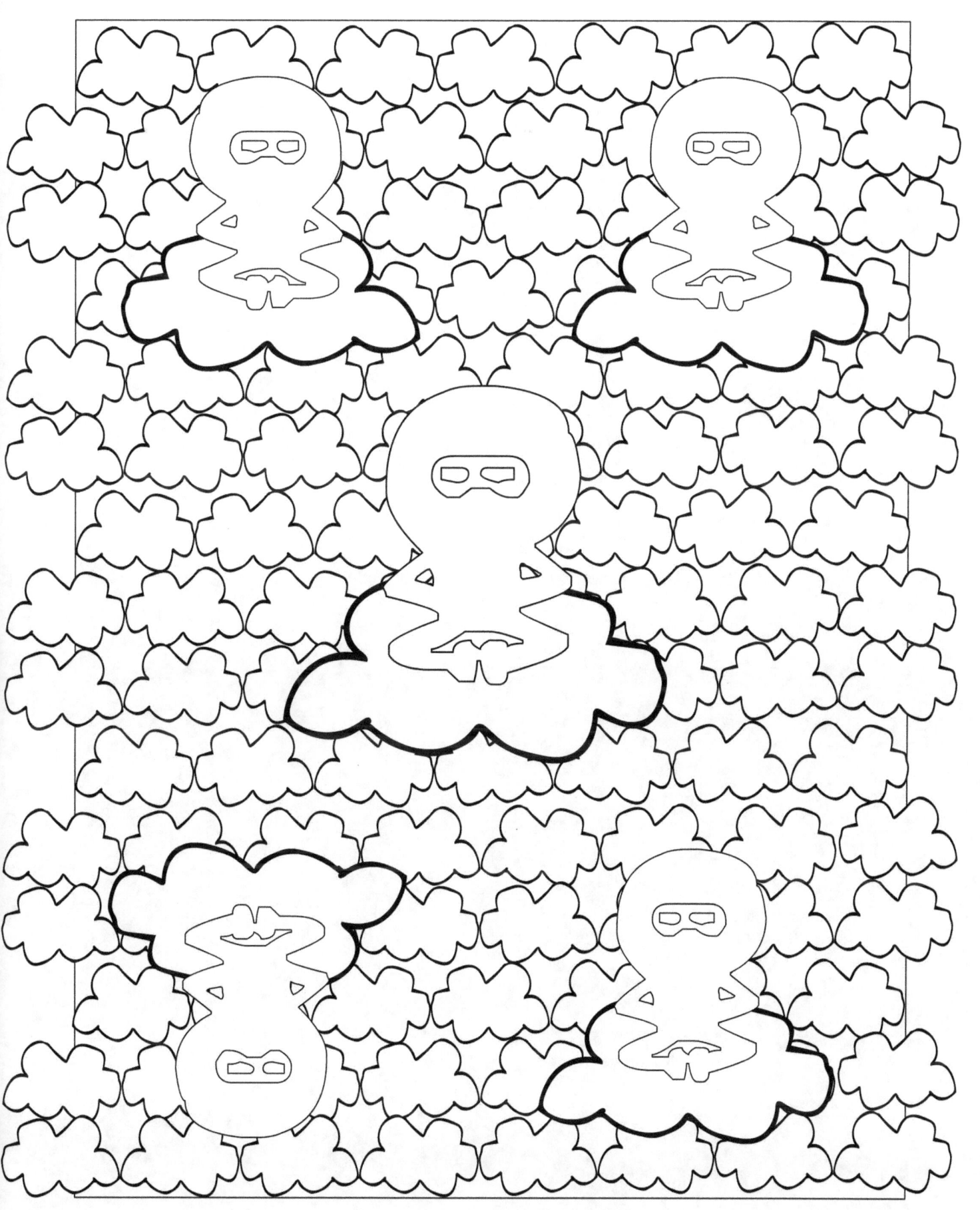

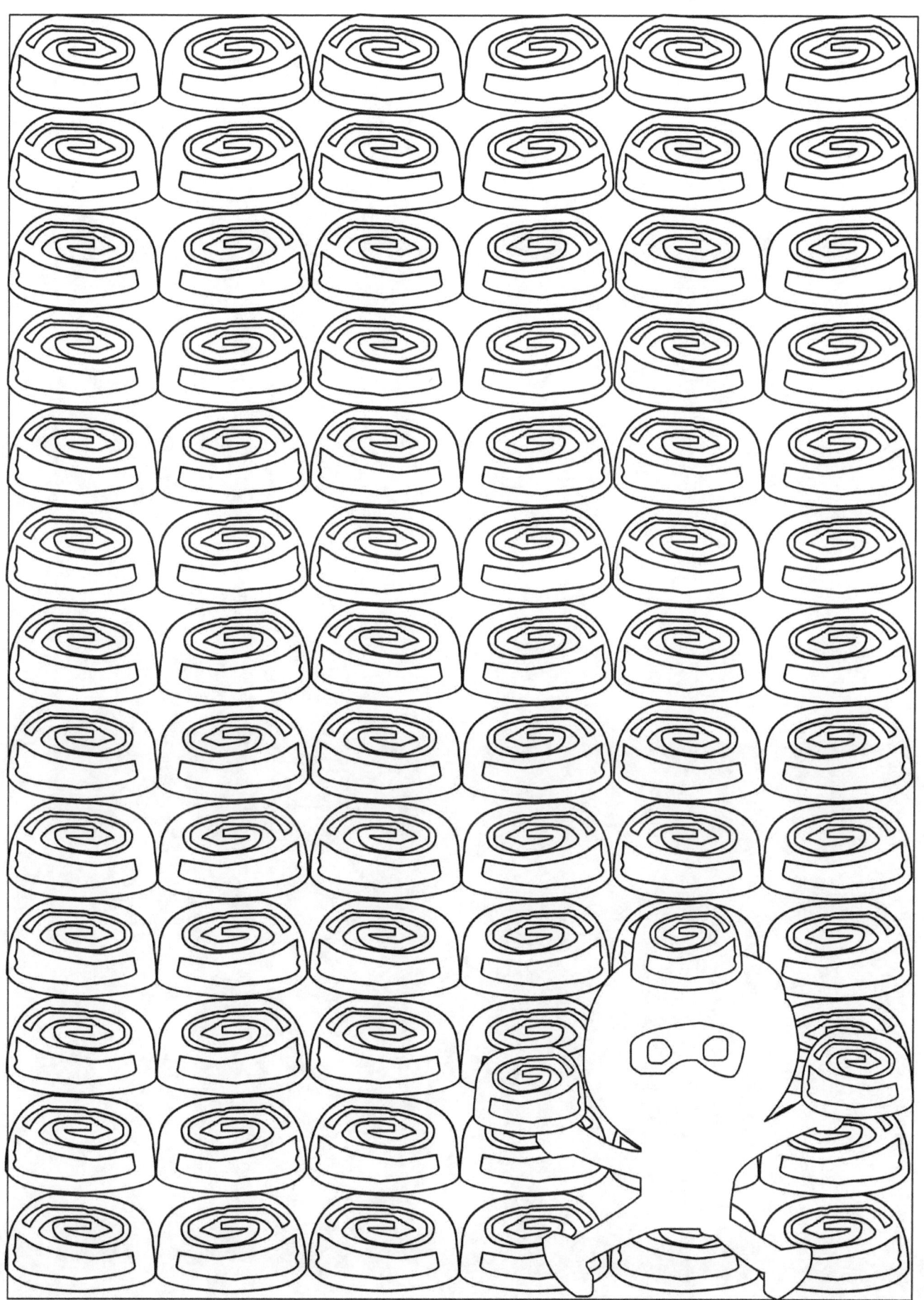

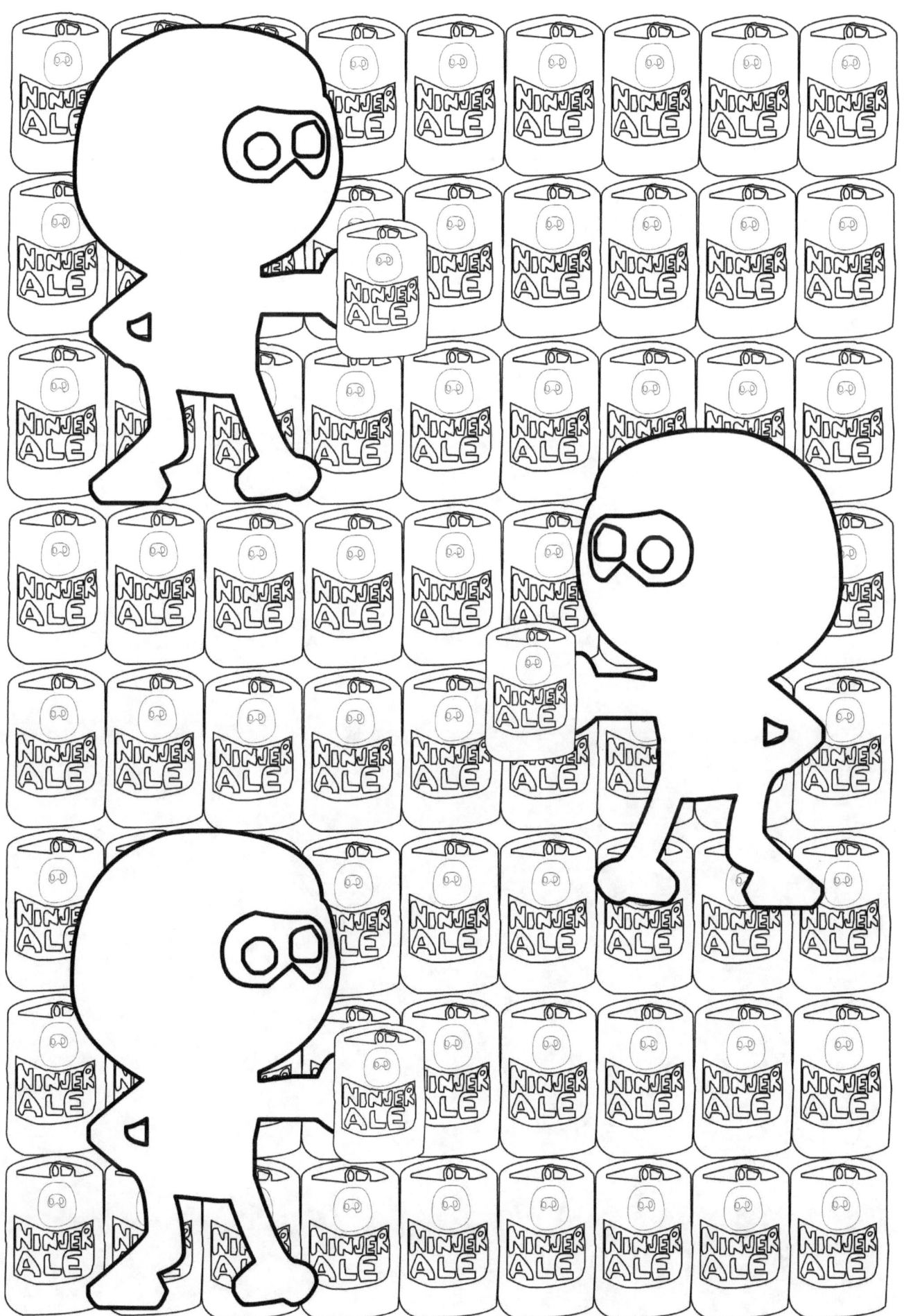

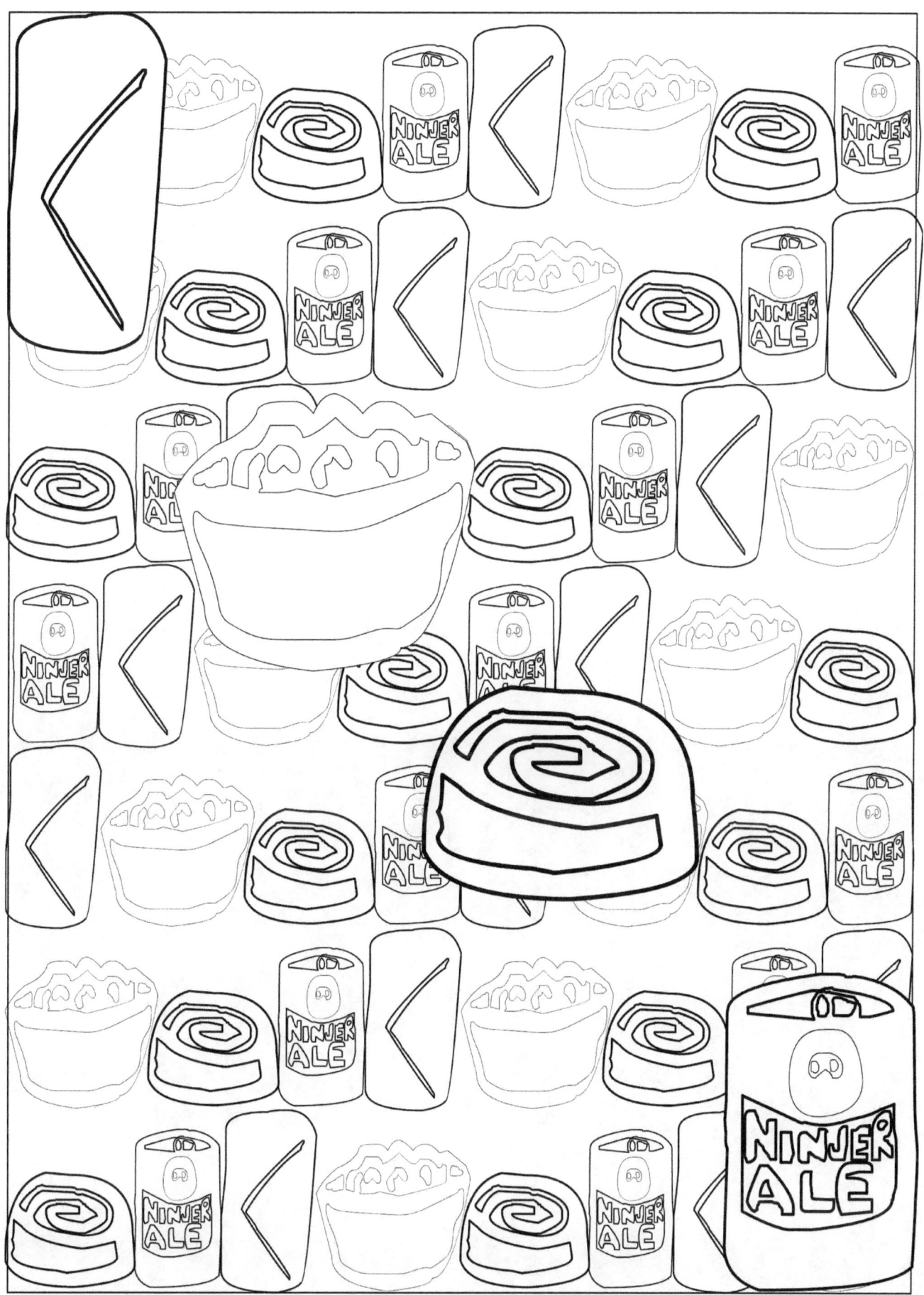

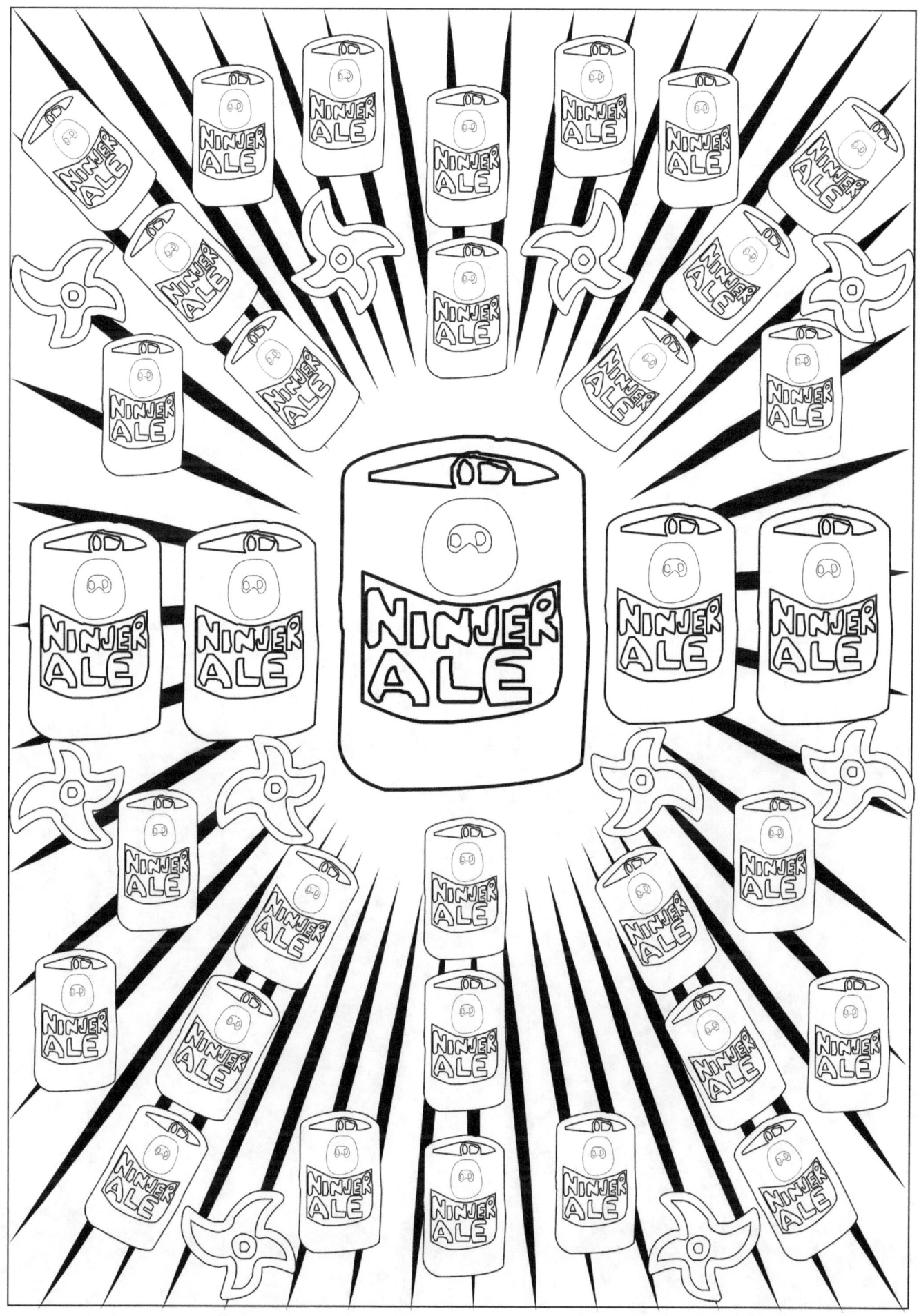

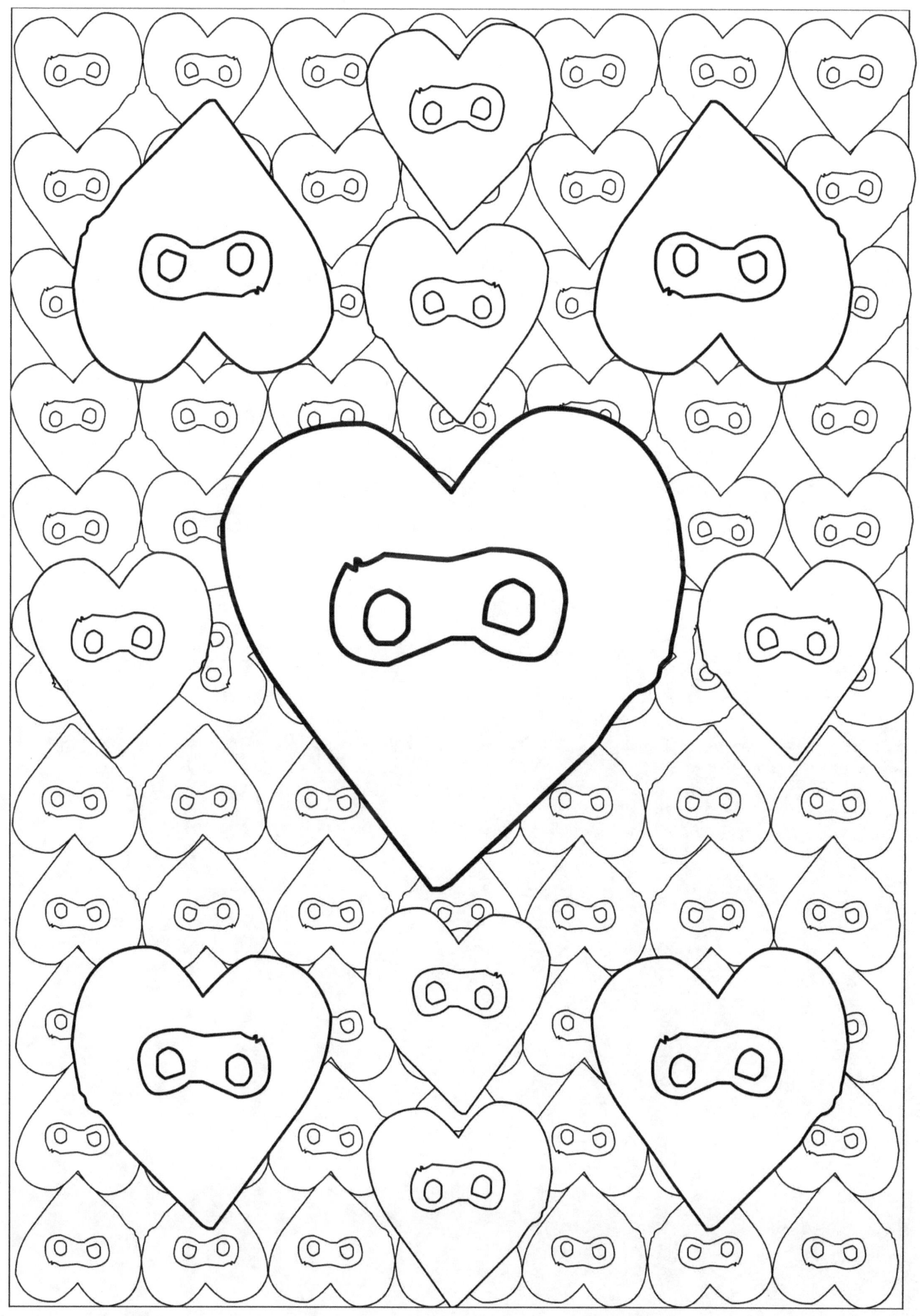

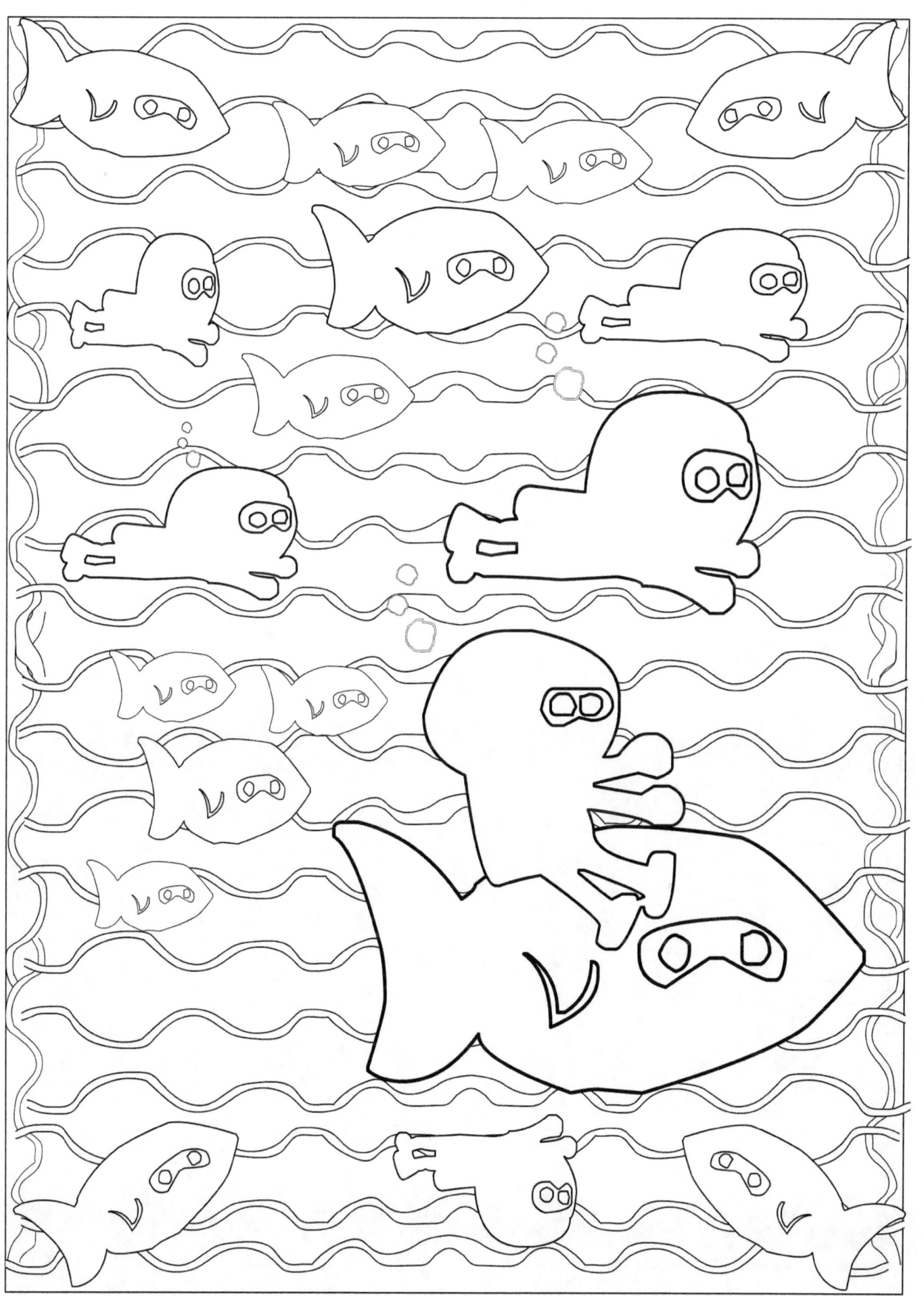

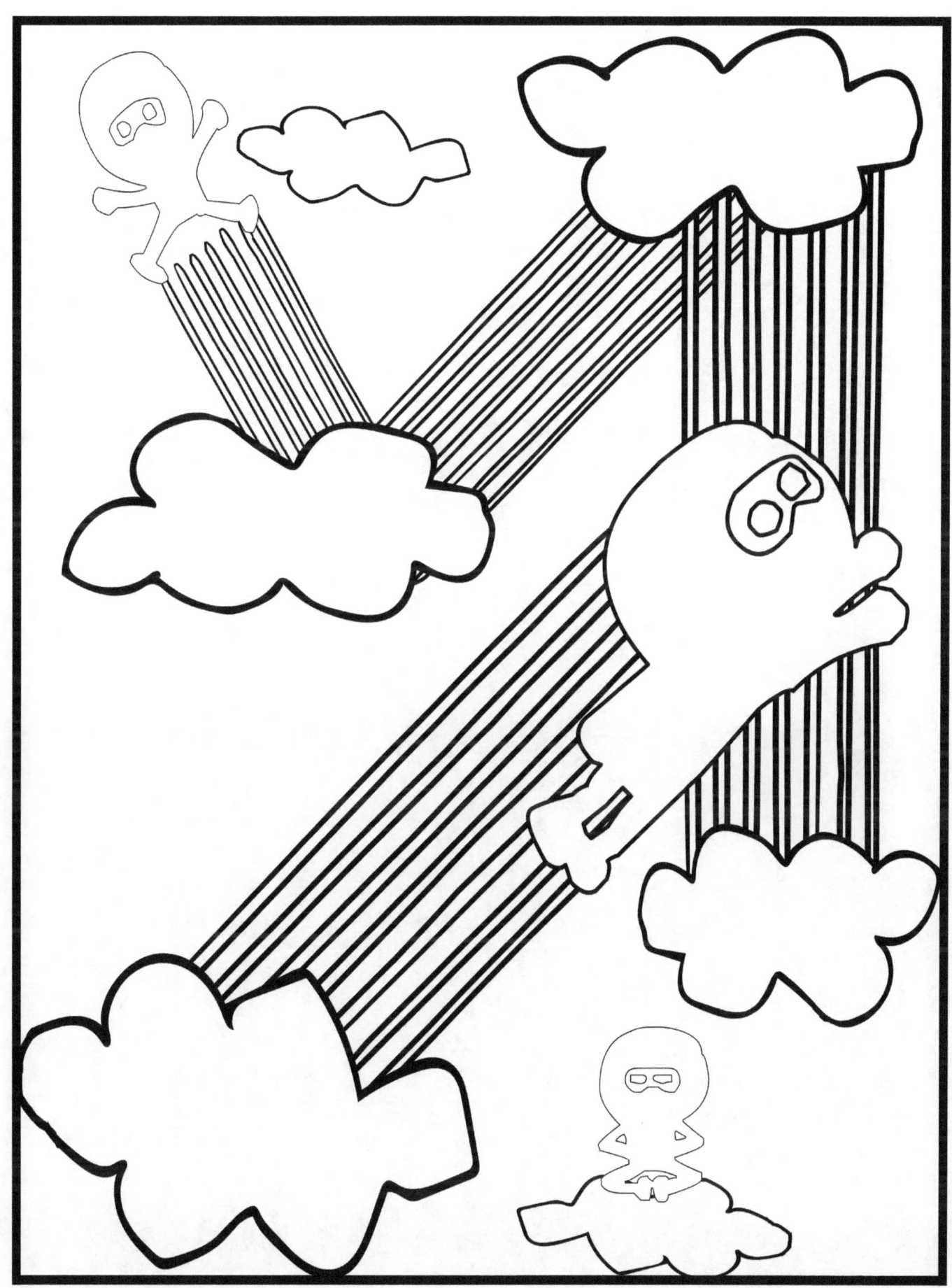

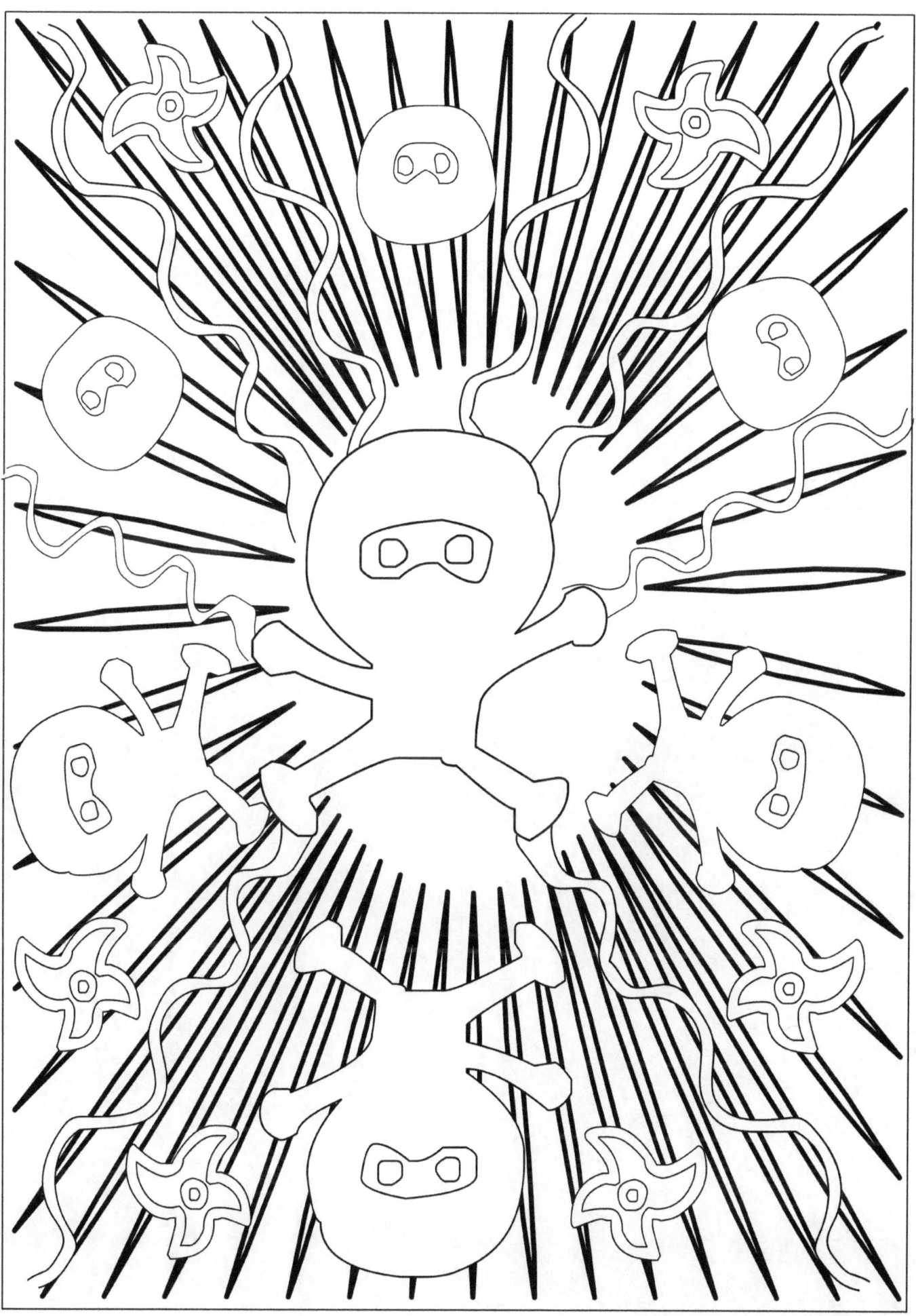

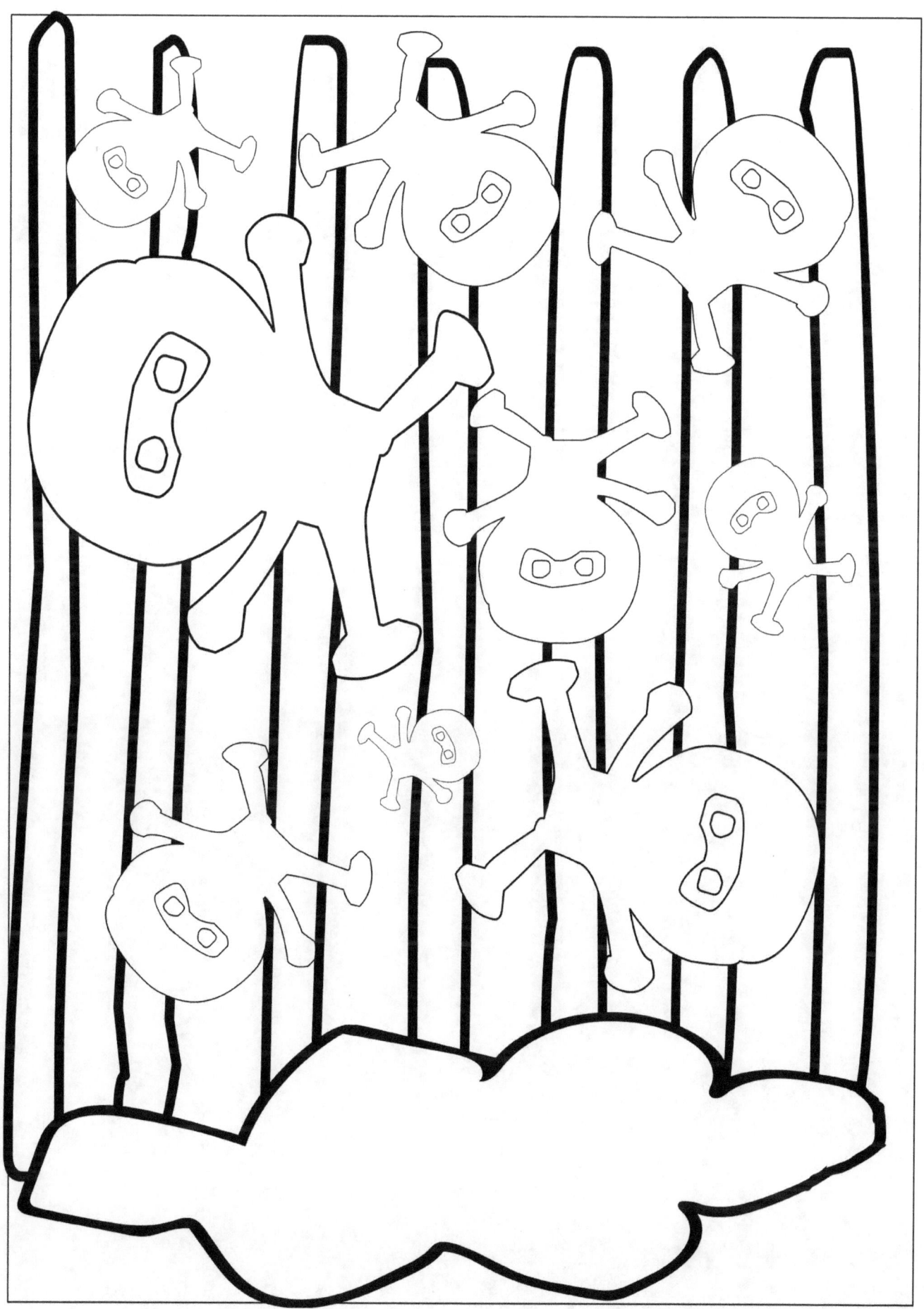

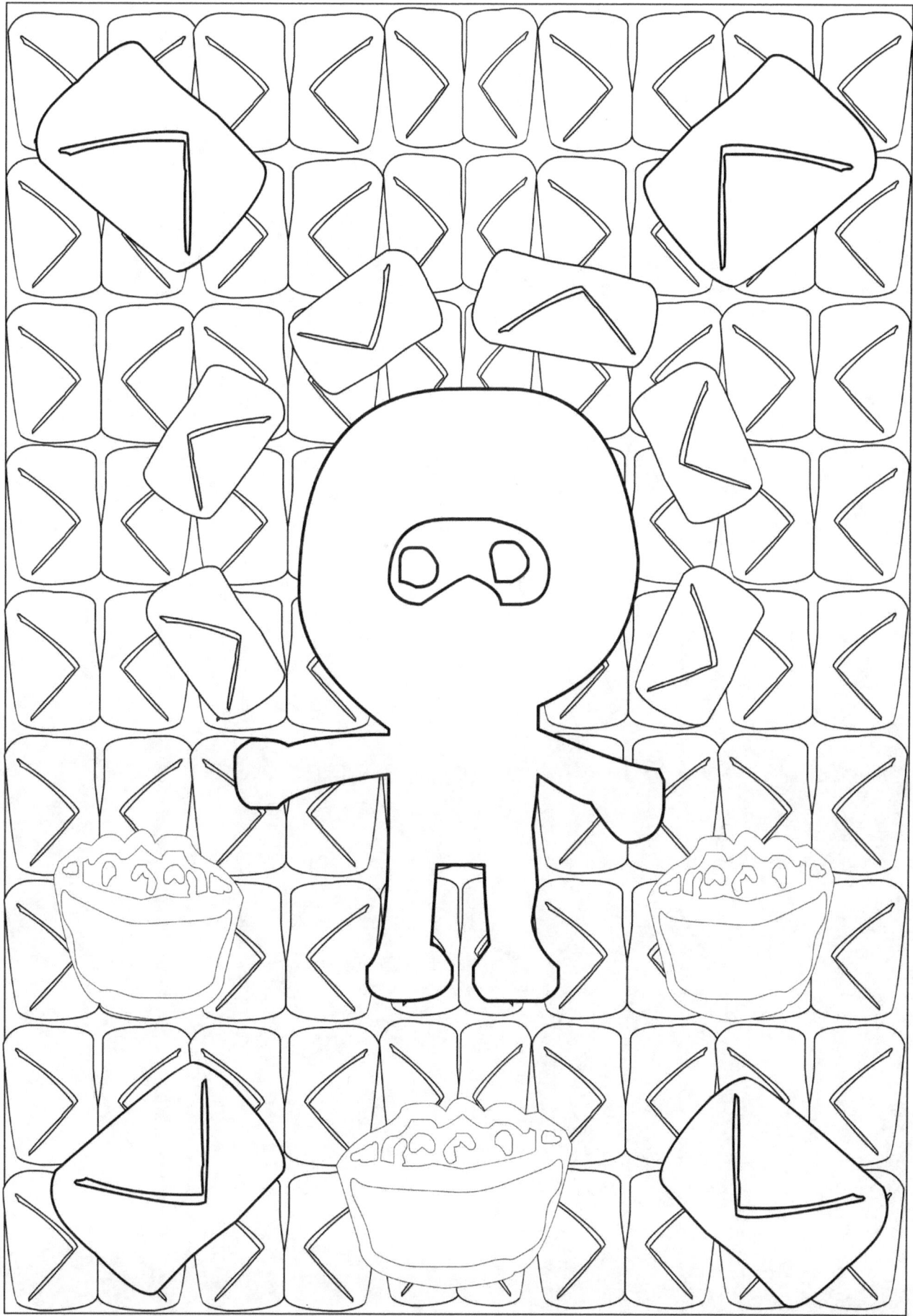

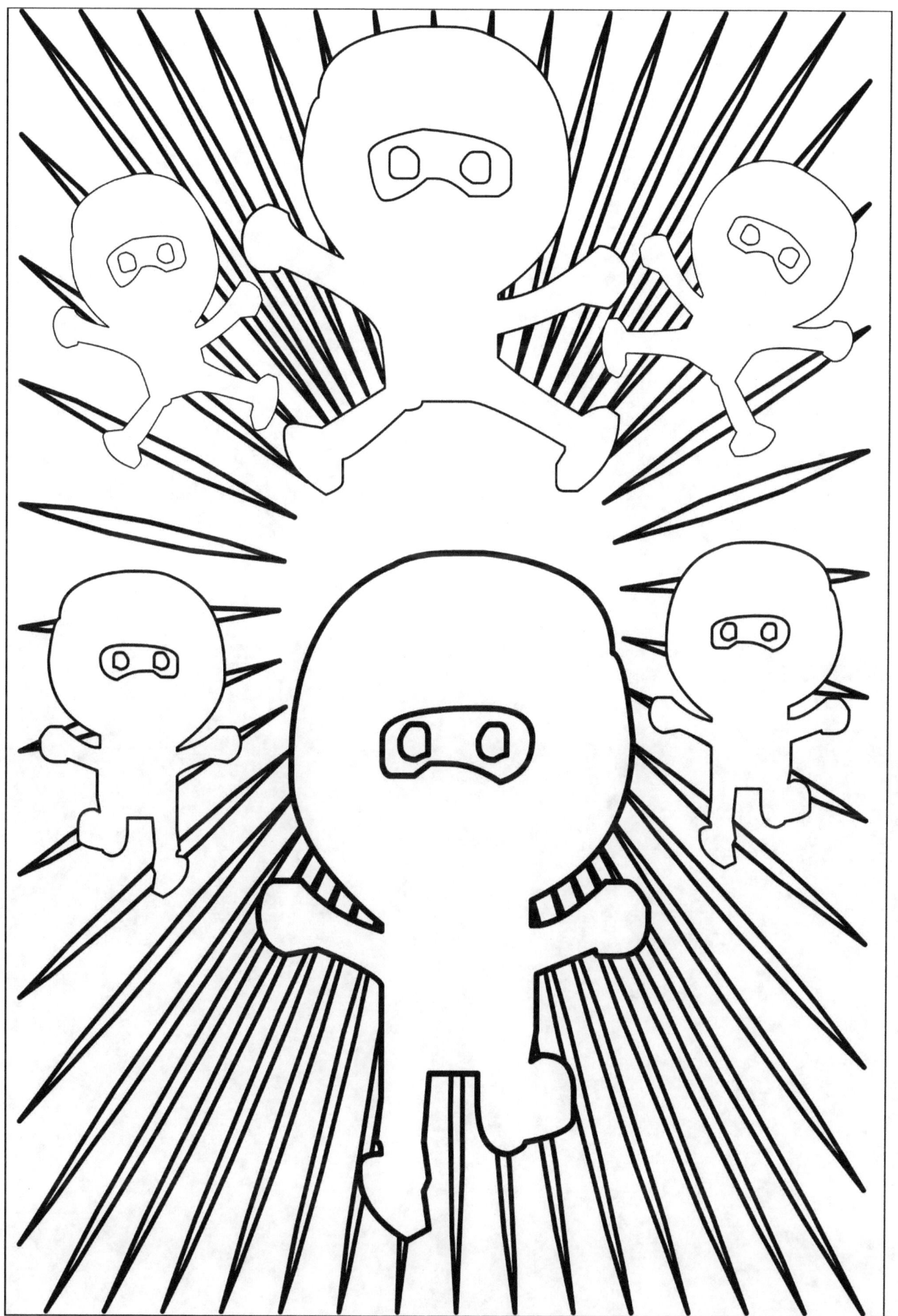

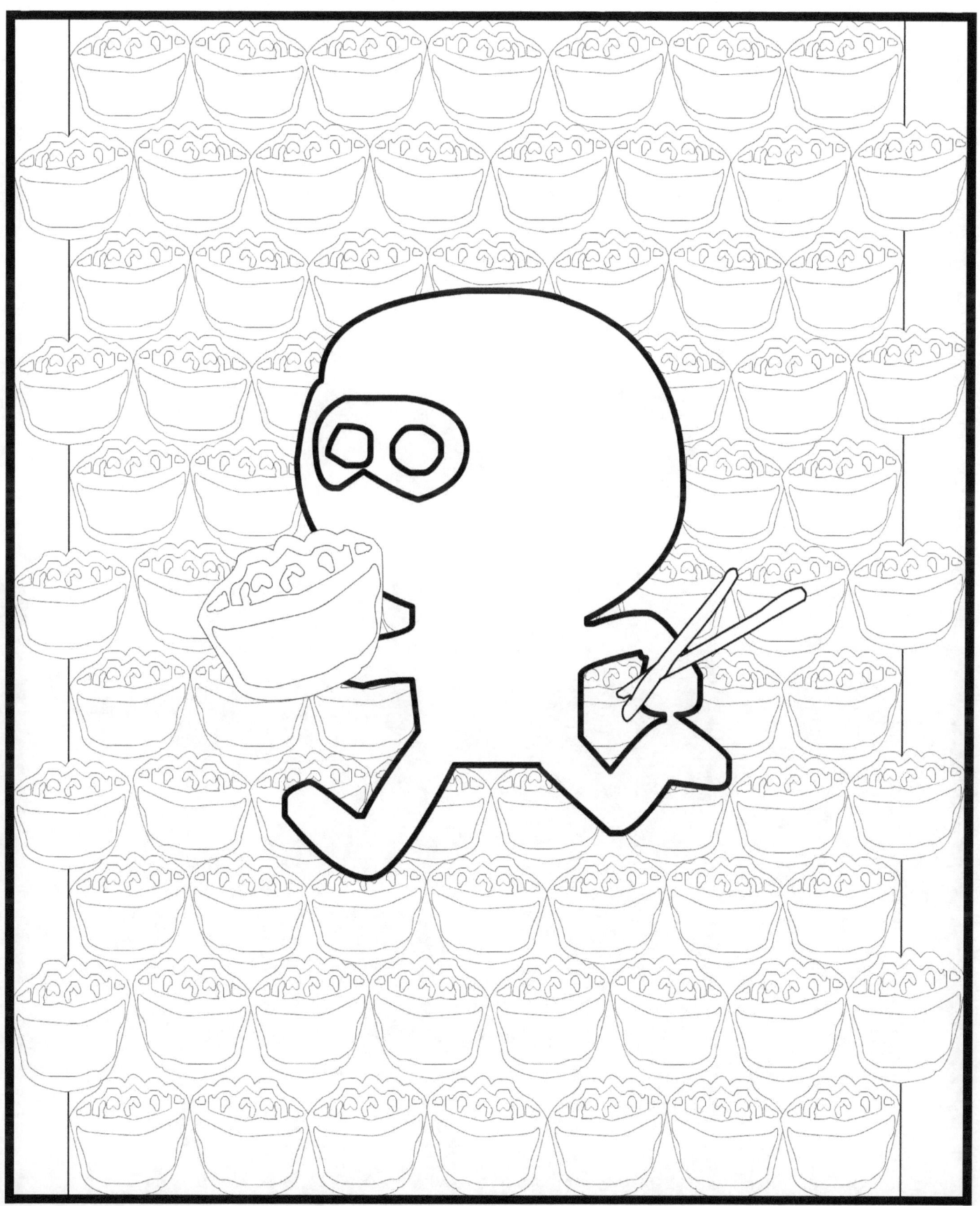

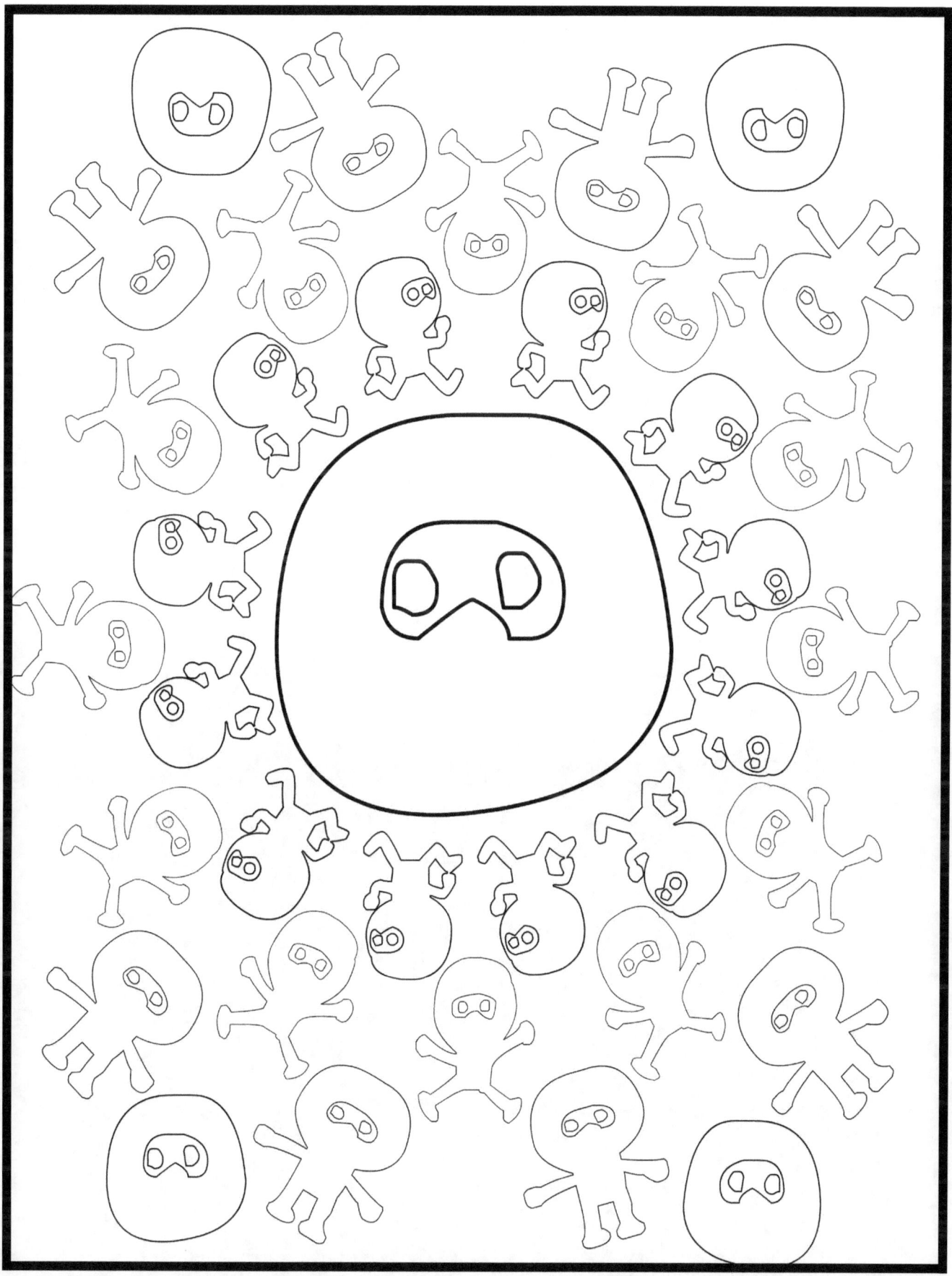

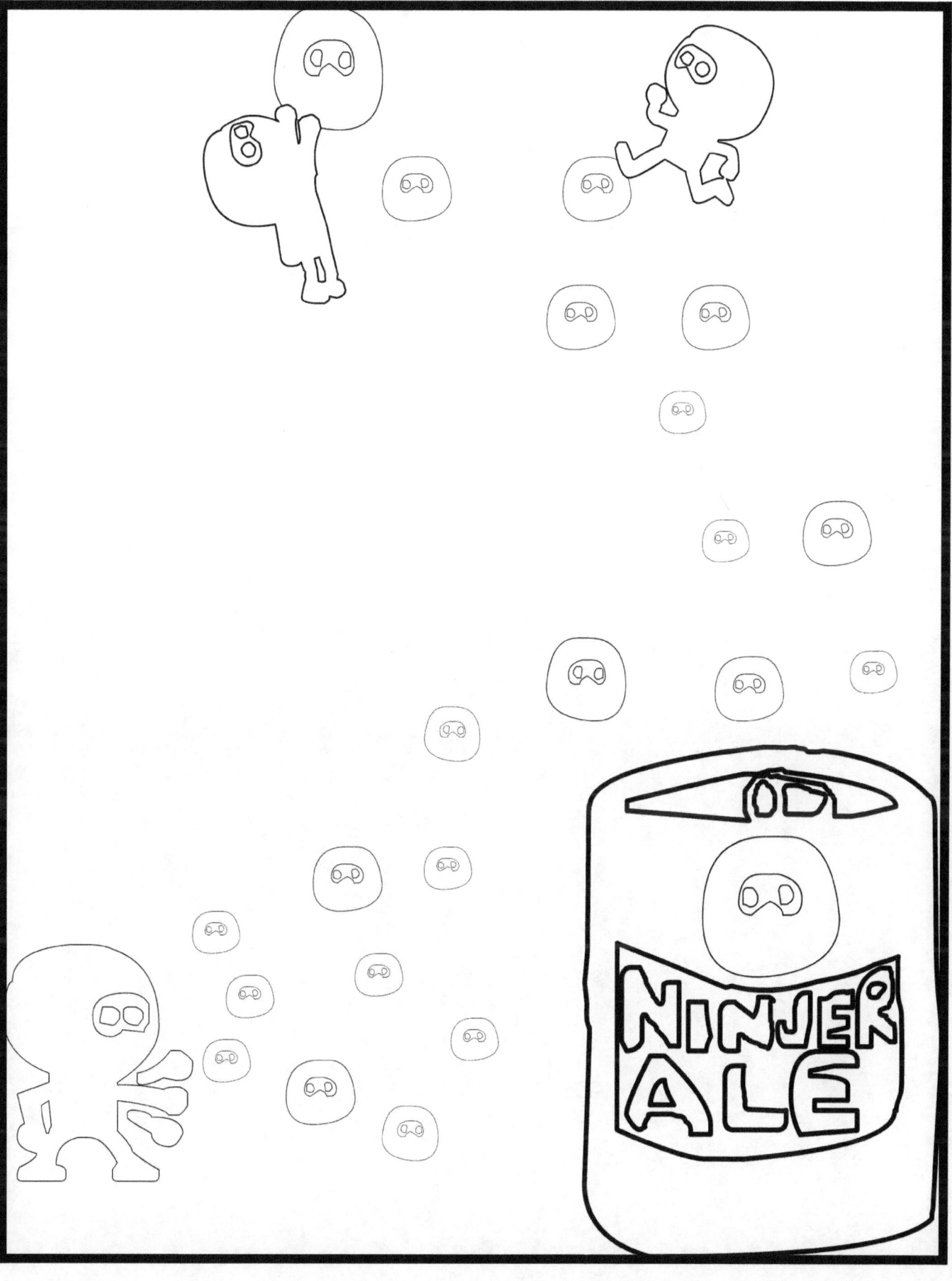

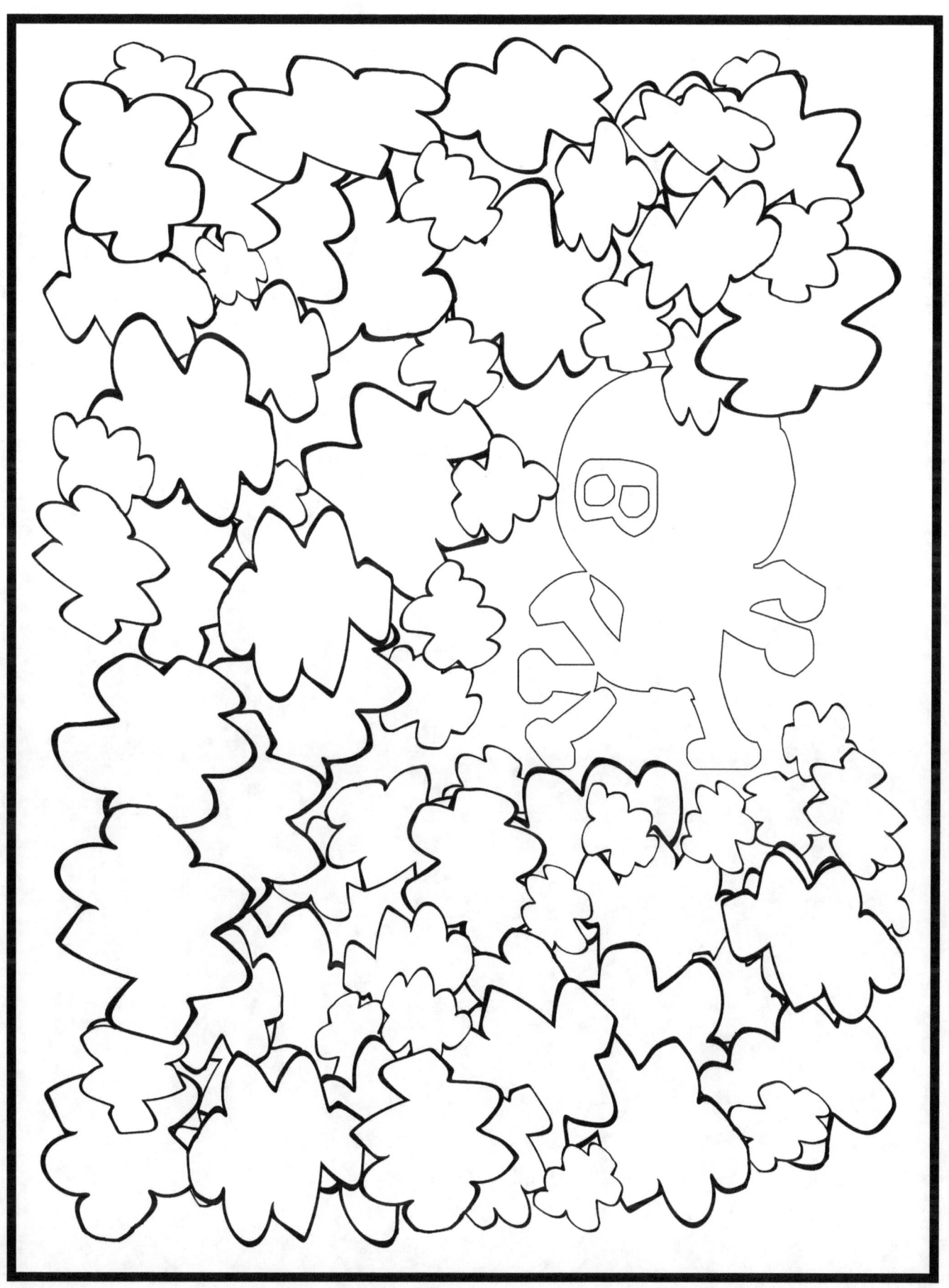

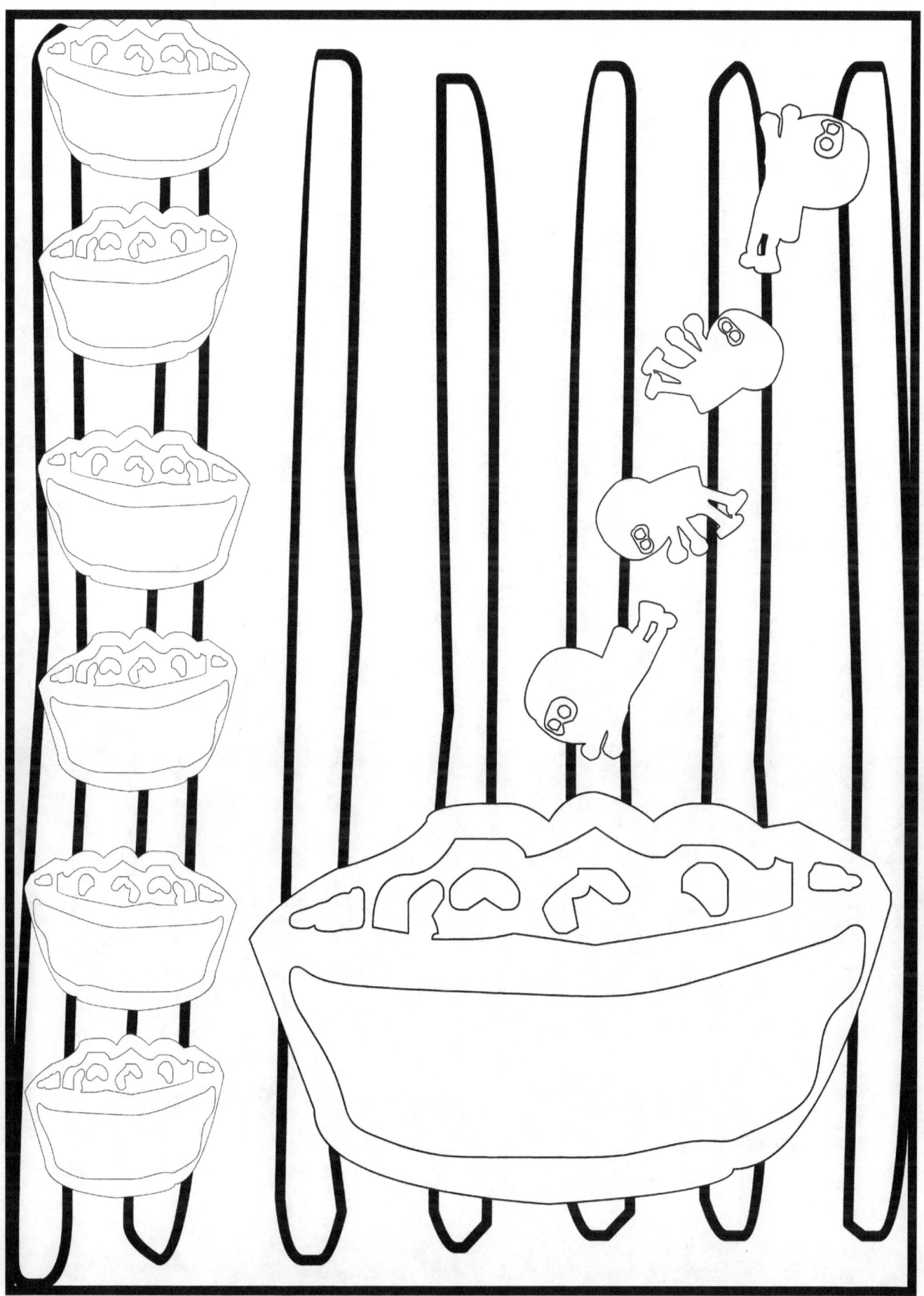

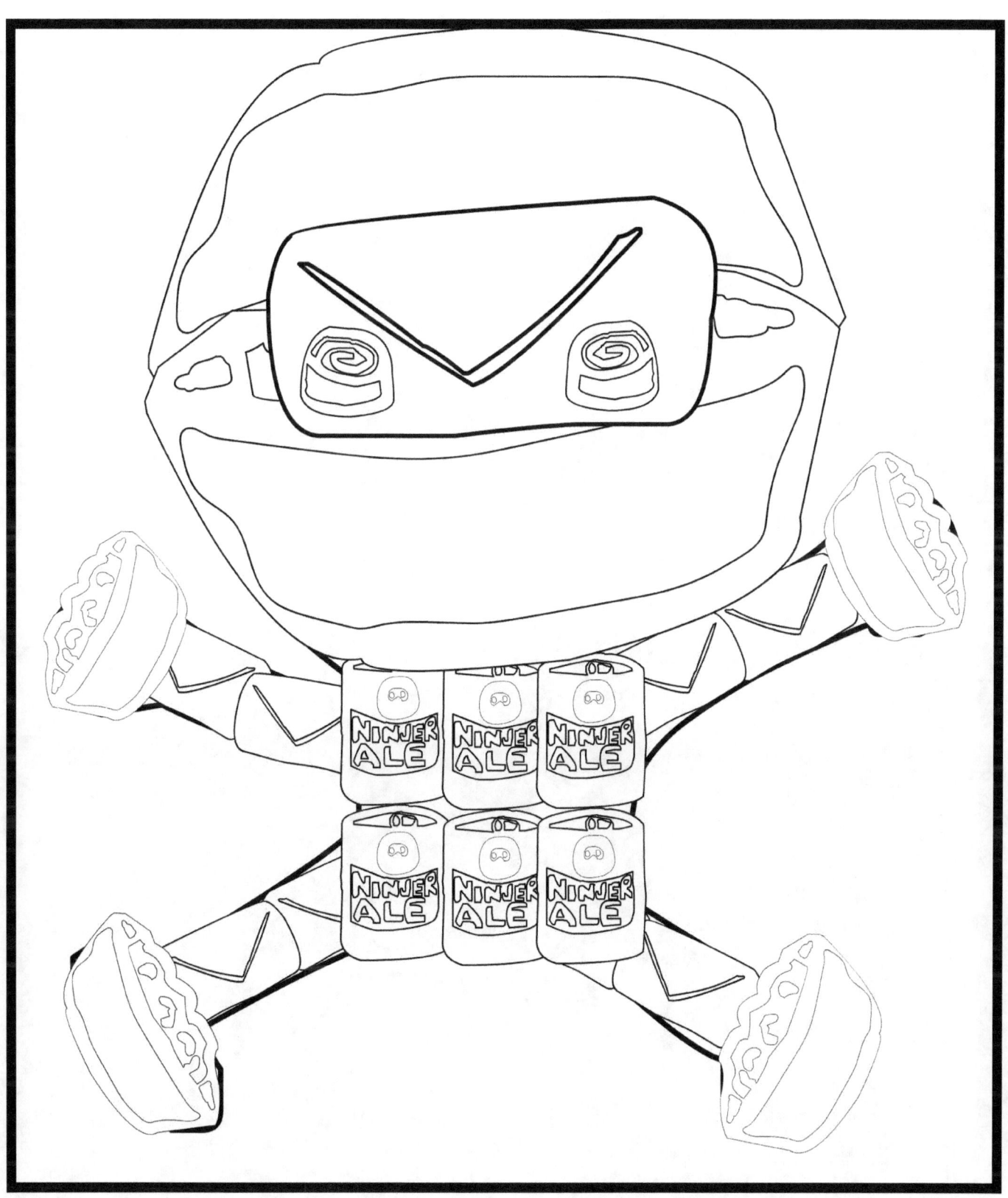

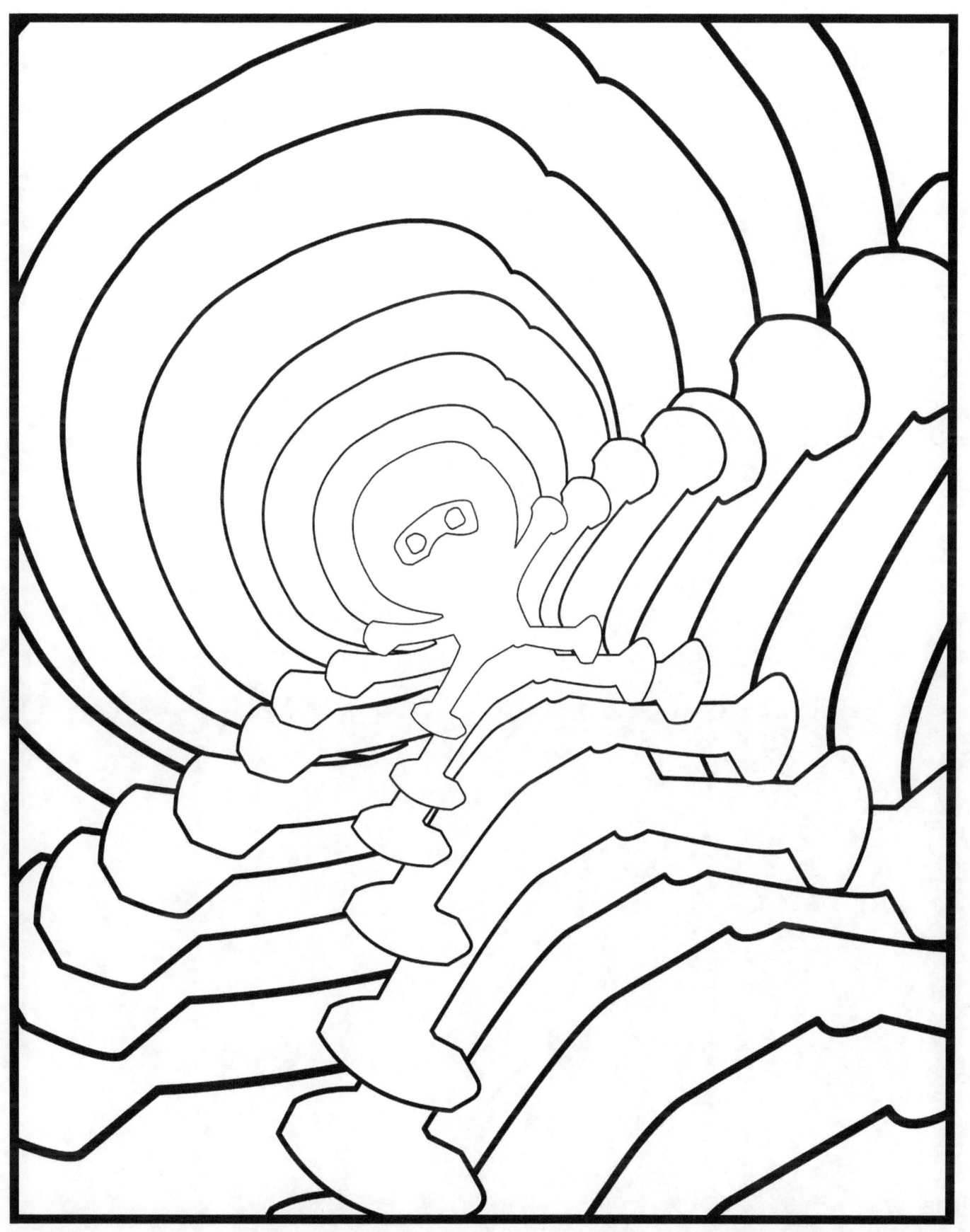

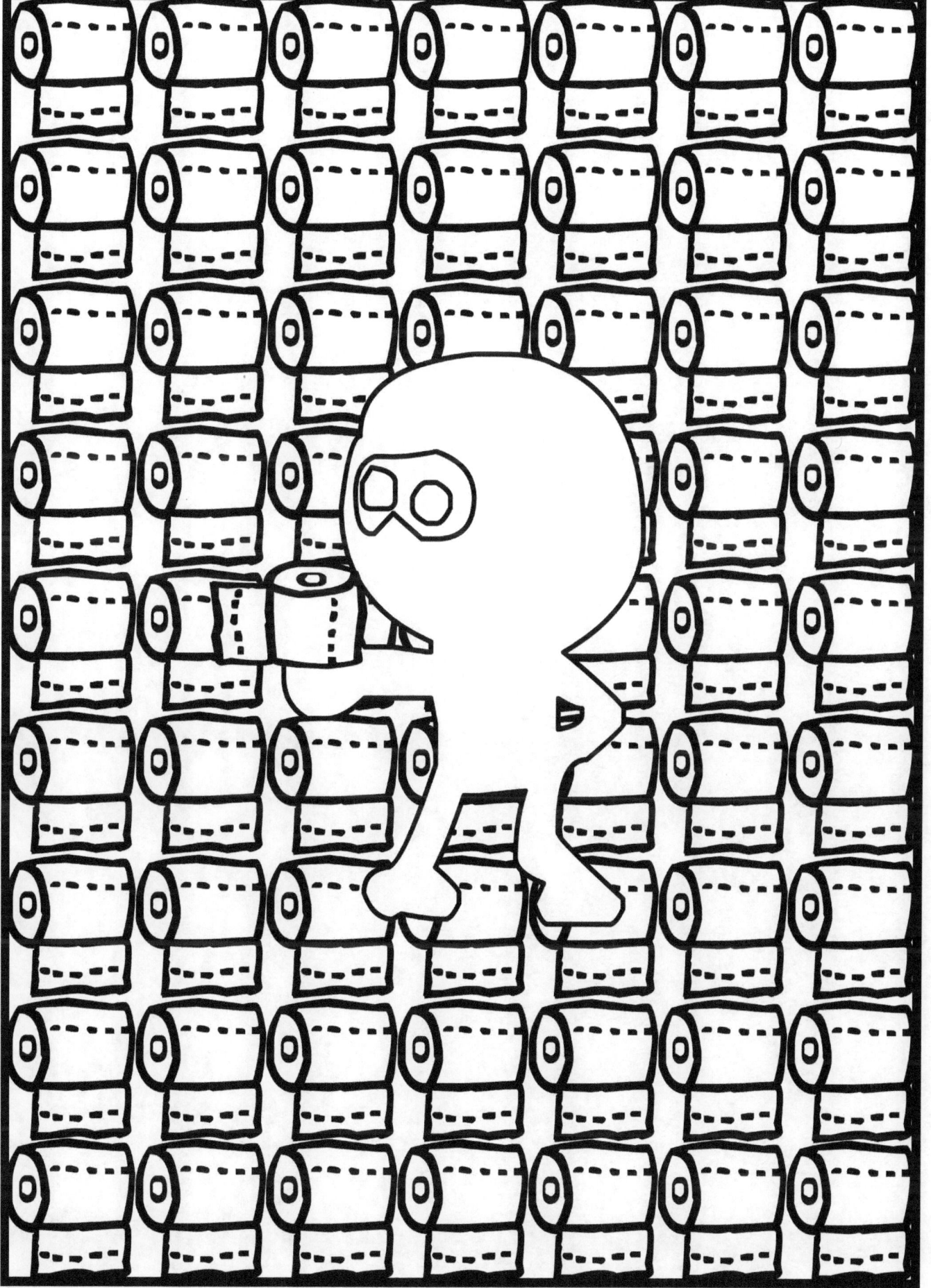

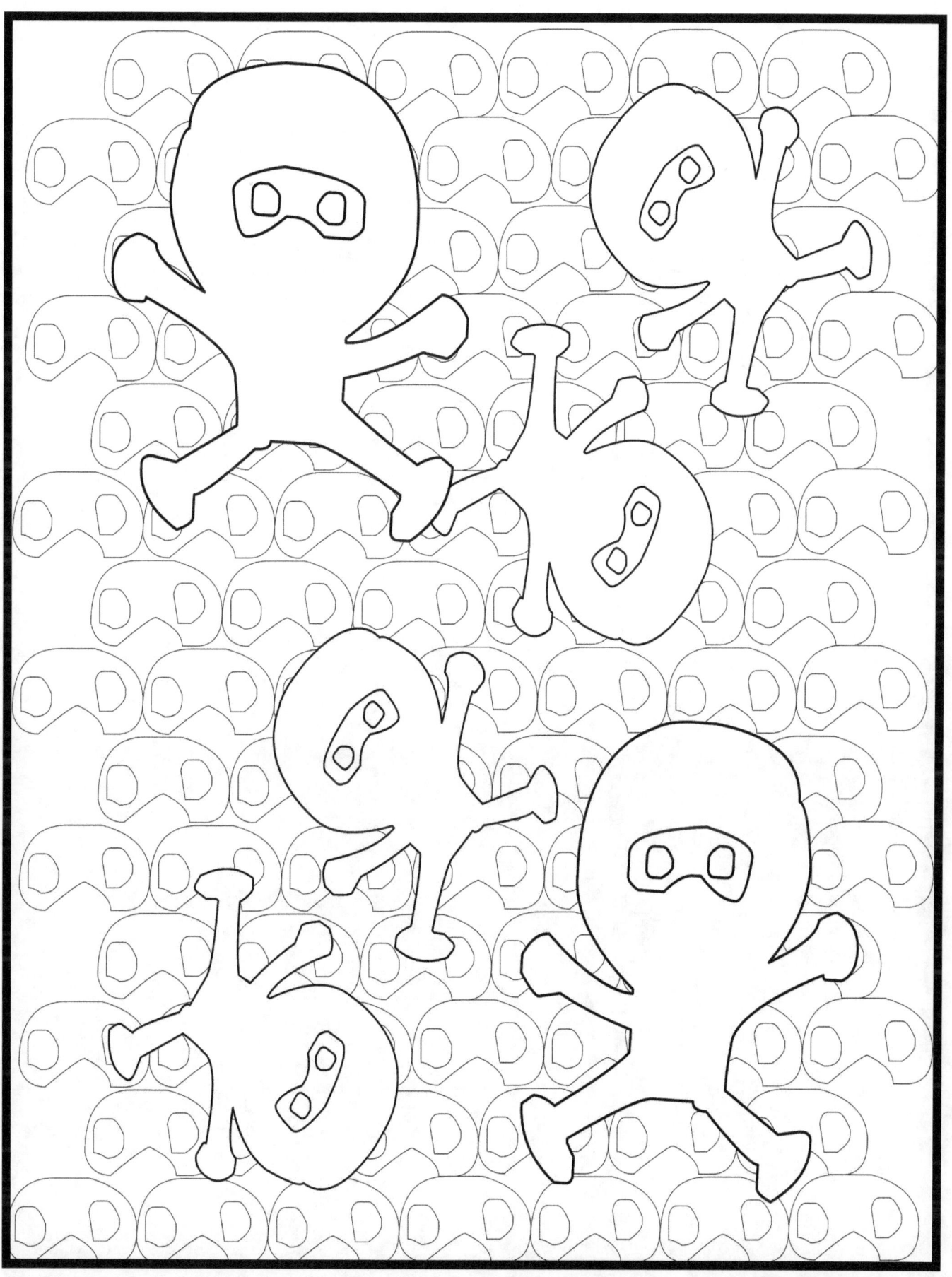

Thanks for picking up this coloring book!

Follow me at:
https://www.facebook.com/mackeral1964
@carrolltoonz (Instagram & Twitter)
ninjacarroll@gufpaht.com
mackeral1964@yahoo.com

www.ingramcontent.com/pod-product-compliance
Lightning Source LLC
Chambersburg PA
CBHW080707190526
45169CB00006B/2285